TWIN CITIES PROHIBITION

Minnesota's Blind Pigs & Bootleggers

ELIZABETH JOHANNECK

THE
History
PRESS

Published by The History Press
Charleston, SC 29403
www.historypress.net

Images are courtesy of the author unless otherwise noted.

First published 2011
Second printing 2012

Manufactured in the United States

ISBN 978.1.60949.127.7

Library of Congress Cataloging-in-Publication Data

Johanneck, Elizabeth.
Twin cities prohibition : Minnesota blind pigs and bootleggers / Elizabeth Johanneck.
p. cm.
Includes bibliographical references and index.
ISBN 978-1-60949-127-7
1. Prohibition--Minnesota--Saint Paul--History. 2. Prohibition--Minnesota--Minneapolis
Metropolitan Area--History. 3. Crime--Minnesota--Saint Paul--History. 4. Crime--
Minnesota--Minneapolis Metropolitan Area--History. I. Title.
HV5090.M6J64 2011
363.4'109776579--dc22
2011012083

Dedicated in loving memory to

Ed Michael
&
my red-haired nephew,
Andy Johanneck

CONTENTS

ACKNOWLEDGEMENTS

First and foremost, I must acknowledge my family, who offered me unlimited support. They include my lovely and talented mom, Marie, and my good-natured old dad, Lenus Johanneck, along with my siblings, Philip, Steve, Kevin, Bob, Jeff, Annie (Hammerschmidt), Pete and Danny, and their wonderful families. Along with them, I have received the support of my friends Cindy Bernardy Lavin and her husband, Bill, from Granite Falls, Minnesota. A special thank-you to my dear friend Monica Fischer for letting me use her story in the "Women and Crime" chapter.

My boss, Sarah Thapa, and our employer, Park Nicollet Methodist Hospital, once again agreed to make time for me to complete my book, and I am grateful for the consideration. I had the support of my co-workers, Kathy Lambert, Paul Lesnieswski, Shirley Sanon, Katie Nielson, Jenny Rux, Mark Skalsky, Annie Scott and Cassie Wold, who good-naturedly pitched in when extra help was needed.

My thanks go out to the management of the following businesses: the 5-8 Club, Foshay Tower (W Hotel Minneapolis), St. Paul Hotel, Phil's Tara Hideaway, Breezy Point Lodge and Bootlegger's Supper Club.

I am extremely grateful to Mark Evans for filling in the blanks of his grandfather's story and for agreeing to co-write his grandfather's chapter with me. Thank you to Gary Revier of Redwood Falls for providing photos and document images for my chapter about the Redwood Falls bank heist.

I am grateful to Melanie Dunlap and Penny Anderson for joining me on my adventures. And last but not least, I thank my children, Geoff and

Kasey, and their significant others, Adriane (who provided the information about the liquor raid in New Ulm) and Shawn Johnson. I am grateful for grandsons Jojo and Jayvyn, to whom I have the opportunity to leave this modest legacy of my version of Minnesota history. Take what you like and leave the rest.

INTRODUCTION

T here are, within the state of Minnesota, speakeasies and Prohibition-related historical sites that are still operating today as legitimate businesses. They are the inspiration for this book. Speakeasies, also referred to as "blind pigs," were business establishments that served liquor without proper licenses when the sale of liquor was prohibited by the Eighteenth Amendment—the "Noble Experiment."

The 1920s and '30s in Minnesota are a fascinating time in history. Besides Prohibition, there was a friendly relationship between Canadian distillers and local gangsters and a style of law enforcement that tried to make the best of a bad situation through unconventional policies. Like in the rest of the country, our economy boomed and crashed like the percussion section of a junior high school band.

The era is commemorated culturally today in a variety of ways. The memory of Minnesota's Andrew J. Volstead from Granite Falls, who nurtured and guided the Eighteenth Amendment into law, is kept alive across the country. For instance, there is the Volstead Restaurant located at 125 East Fifty-fourth Street in New York City, which serves a tongue-in-cheek cocktail called Volstead Lemonade made with Ultimat vodka, fresh lemon, sugar and club soda. For lunch, one can dine on the Volstead Burger, an eight-ounce burger topped with lettuce and tomato, with the option of adding cheese, bacon and sautéed onions. I'm a little disappointed there isn't more to it than that, but then I suppose Volstead would have had a rather conservative diet.

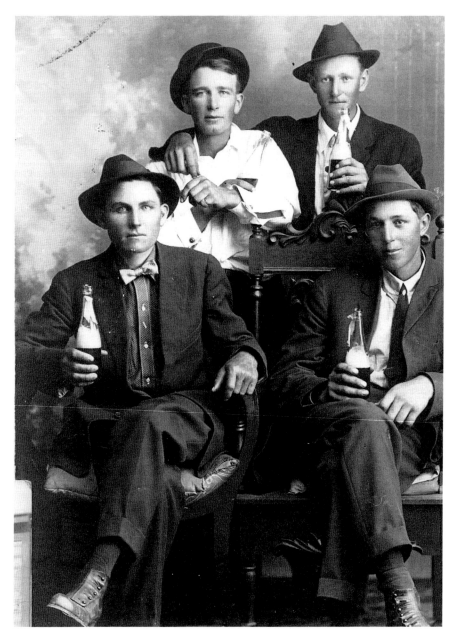

Minnesota men enjoying a beer. *Photo courtesy of Monica Fischer, Wabasso, Minnesota.*

Within this book, you will find a description of a number of former speakeasies in Minnesota that continue as legitimate businesses today. The idea of having refreshments in a vintage speakeasy appeals to certain types of diners—of whom I am one. There is a tiny perking up of the rebel in some of us, in much the same way the Prohibition era found some of the elite delighted to risk bumping elbows with the seedier class, covertly sneaking into back rooms and basements, only to brag about it behind their hands to friends the next day after church. Oh the thrill of being common!

Here in St. Paul, the Great Minnesota History Theater, founded by Lynn Lohr in 1981, has featured productions written by nationally recognized playwright Lance Belville revealing tales and folklore of the 1920s and '30s. Those plays include *Scott and Zelda*, a performance about Minnesota writer F. Scott Fitzgerald and his tortured wife, Zelda, an icon of the flapper era whose antics and literary success defined the Roaring Twenties. In much the same way our nation experienced the giddy heights of the 1920s and the devastating economic bust of the 1930s, Belville's play documents the boom and bust of the Fitzgeralds, whose haphazard lives went up in flames fueled by alcoholism and madness.

Nina, Madam to the Saintly City, based on the real-life madam Nina Clifford, details the hypocrisy of the city of St. Paul promoting itself as a pillar of virtue while crooked cops and politicians were encouraging women to open candy stores serving children and then collecting graft from their backroom brothels. It was a tax, really, for conducting an illegal business within the city limits. Nina's was a real brothel, which served, among others, many of the city's finest decision makers and policy setters. There is a wonderful coffeehouse on the corner of Selby and Western Avenue in St. Paul that is named after the famous Nina. On the lower level, you will find Common Good Books, Garrison Keillor's bookstore, promoting many of Minnesota's writers.

During the process of pulling together the events that constituted our state's Prohibition era, I discovered stunning similarities to the economic and social events taking place today. The parallels are unmistakable, and though you may not see the connection at the beginning of this book, I trust that by the end you will.

A DIFFERENT TYPE OF LAW AND ORDER

MINNESOTA NICE

According to the Wikipedia definition of "Minnesota Nice," Minnesota is the second most agreeable state in the nation. One might argue that we should be in first place, but we don't want to make a fuss. We Minnesotans take pride in being nice, but there are those who have besmirched our good title with their bad behavior, adding a bit of spice to the otherwise vanilla narrative of who we imagine we are. Minnesota has been home to some deliciously shady characters during an era of rapid economic expansion and, later, during the depths of the Great Depression.

It is not lost on me that the era of Prohibition lit the fuse for an explosion of crime and underworld activity, making Minnesota one of the top destinations for gangsters, crooked politicians, cops and illegal speakeasies. It spurred an era of whistleblowers and gangland murders.

Unfairly charged by the media with employing economic warfare, farmers and laborers joined forces to create a new political party with which to defend themselves from abuse by the elite, who were already stacking the deck against the middle class. Sometimes it's hard to tell who the real gangsters are. It is surprising to me that the same issues being used to divide our country today were used back then. Immigration, accusations of socialism and communism and a lack of patriotism have all been around the block before. The more we study history, the more we can see the battle

between the wealthy and the poor, between good and evil. I love my state, and I am proud to hail from here. In spite of the rabble, Minnesota's good-hearted citizens have prospered and prevailed. Isn't that nice?

THE SHAME OF MINNEAPOLIS

Minneapolis, St. Paul's twin city across the Mississippi River, was memorialized in an article called "The Shame of Minneapolis" written by Lincoln Steffens for *McClure's* magazine in 1903. It tells the history of Doc Ames, who was, shall we say, a very bad man. In his article, Steffens describes Minneapolis as a "New England town on the upper Mississippi" and the metropolis of Norway and Sweden in America. It was settled by Yankees "straight from Down East" with a New England spirit. He described Minneapolis as having "a small Puritan head, an open prairie heart, and a great, big Scandinavian body." He said its citizens worked hard, made money, stayed sober and were satisfied and busy with their own affairs, without much time for public business, leaving the enforcement of law to others.

He claimed that those who were left to govern the city—"the loafers, saloonkeepers, gamblers, criminals, and the thriftless poor of all nationalities"—despised, more than anything, strict laws. Without the Irish to boss them around, they followed the lead of Doctor Albert Alonzo Ames, the son of a pioneer who moved his family of six sons from Illinois to Fort Snelling in 1851, before Minneapolis had even been founded. The younger Ames received a medical degree from a college in Chicago and returned home at the age of twenty-one. Plying his skills with a gracious bedside manner, Ames became a beloved member of the Minneapolis community.

THE TAVERN OF NORTHFIELD

212 Division Street, Northfield, Minnesota

I think, in a previous life, I was a bad girl (not a famous one or anything) who hung out with bootleggers and rumrunners during Prohibition. I am fascinated by the 1920s and '30s. I still have a tendency to be a little on the naughty side, which may be cellular memory, but more likely it is the result of having grown up under a strict family regime and attendance at an uncompromising Catholic grade school. A

Relaxing in the courtyard of the Tavern, a former speakeasy located under the Archer House in Northfield, Minnesota.

girl needs to have a little fun, so it makes perfect sense to me that I would be drawn to former speakeasies, and Northfield in southeastern Minnesota has a wonderful example called the Tavern of Northfield hiding under the fabulous Archer House.

This former speakeasy is located in the old cistern. Clever, right? It is now an intimate little restaurant with heavy, dark furniture and thick stone walls—and beneath it all, a tangible sense of history.

Remember, it was our own state representative Andrew Volstead from Granite Falls, Minnesota (a community that, ironically, also has a former speakeasy called Bootlegger's on the edge of town), who signed the Eighteenth amendment leading to the prohibition of alcohol. Congress meant well. My own opinion is that the more laws you make, the more laws there are to break and enforce. It gets complicated. And let's face it: you simply can't legislate morality, though lord knows we continue to try.

My friend Melanie and I slunk in through the back door of the Tavern and looked around for a discreet place to sit where we wouldn't be spotted. Nah, I'm just kidding. Discretion isn't our strong suit. But eating is. We chose a table in the shady courtyard out back and ordered up a couple cold, foamy...floats, made with Schwan's ice cream. I used to make corn dogs at the Schwan's plant in Marshall,

> *Minnesota. If you want to know how it's done, I've got the scoop. Oh man, do I wish I could have made ice cream instead! That would have been one jukin' pun! (Insert a high-five here.)*
>
> *I'd love to take a tour of every speakeasy in the state. I wonder if there is such an itinerary. I bet our Minnesota Office of Tourism could advise me. In the meantime, I'll try to behave, and maybe Melanie will let me continue riding along with her on Saturday afternoon adventures around Minnesota.*
>
> *—Minnesota Country Mouse*

It was to the detriment of the community that Ames also had a dark side. He catered to the "vicious and the depraved," offering another drink to the drunk and convincing law enforcement to drop charges against criminals. He was a vain man and adored being commended and praised. As a politician, he enjoyed the office of Republican mayor and then twice served as a Democrat. He ran for Congress but failed to be electable outside his hometown. After serving his terms, the people of Minneapolis assumed he would retire from politics. He was headed in a downward spiral, neglecting his family and then separating from his wife altogether. While sitting in a local saloon, he received a note from his daughter letting him know that his wife was on her deathbed and wanted to see him and offer her forgiveness. He responded with an obscene statement scribbled across the note. Banned from the funeral, he sat in a carriage, observing and smoking a cigar, and later made a ridiculous scene.

His behavior should have ended his career, but he was elected mayor of Minneapolis one more time, a reformed man. In his article, Steffens claims that Ames "set out upon a career of corruption which for deliberateness, invention and avarice has never been equaled." His first course of action was to turn the city over to outlaws, who would answer to the police. His brother, Colonel Fred W. Ames, was appointed chief of police. Norman W. King, a former gambler, was made detective. King was ordered to create a force of thieves, pickpockets, confidence men and gamblers. Some were released from the local jail to join the force. The men were divided into departments, according to their trade, and dispensed across the city to set up a system for collecting graft—payments made to keep their criminal activities viable. Irwin A. Gardner, who was a medical student in Dr. Ames's office, was appointed a special policeman for the purpose of finding young women for brothels.

The new chief of police reviewed the work of the city's 225 police officers, dismissing the best 107 men and then charging the remaining men for the privilege of staying on the force. John (Coffee John) Frischette, owner of a "notorious" coffeehouse, was made captain of the police force, with the sole responsibility of hiring the "right" men for the job and collecting their payments to serve. Ames then released the criminals from jail, ordering them to advise the underworld that "things were doing" in Minneapolis. Underworld figures were recruited into the city, reporting to Detective King for direction. Gambling was openly allowed, and the population of prostitutes grew.

In Minneapolis, vices were forbidden yet permitted under certain conditions. Saloons were allowed to run along the riverfront. Brothels were essentially "licensed," with fees collected from women showing up in court on a regular basis to pay their fines. The women were encouraged to open "apartment houses" and candy, tobacco and magazine stores, fronting their real businesses. Gamblers and those requiring licenses to operate within city limits were now paying Ames directly. Opium joints and unlicensed saloons were protected by the police. Ames assigned city physicians the duty of calling on the brothels periodically for health inspections and then charging between five and twenty dollars per visit. Eventually, the visits became so frequent that the inspections were suspended, and the visits' purpose became merely the collection of fees.

Ames's activities did not appear to cause the citizens of Minneapolis distress, but they brought in the criminal element, which was invited to stay, as long as it checked in with King and agreed to the terms of the stay. Minneapolis experienced frequent burglaries, with the police department often in attendance. Take, for instance, the Pabst Brewing Company robbery. The police convinced two men to learn the combination of the safe in the brewery's office and then stood guard while the men opened the safe and cleaned it out. Any officer of the law who wanted to actually prevent a crime would have to face the wrath of the mayor's office and possible dismissal.

As one might imagine, it was foolhardy of Ames to trust the men he hired to take over Minneapolis, and infighting ensued. Things were clearly out of control. In April 1902, a grand jury made up of ordinary citizens, headed by Hovey C. Clarke, decided it wanted to take on the Ames gang. Clarke hired a group of detectives with whom Ames was familiar and whom Clarke knew would talk about what they were doing, and the police began keeping an eye on them. Then he hired detectives Ames did *not* know, who found men in jail with grievances against Ames and were ready to spill the beans on the police department. They were compelled to testify before the grand jury under oath.

Mayor Ames fled town an old, broken man, and later his brother also disappeared. A new mayor, Percy Jones, was elected, and the Ames gang on the police force was replaced. Brothels were still permitted within a certain district and were no longer required to pay fines. A gambling syndicate, in danger of being completely shut down, offered the new mayor a deal. If they were allowed to continue their business, they would control crime for the city. Jones turned down their offer several times, and each time a rise in crime occurred. He gave them his final word: "There should be no gambling, *with police connivance*, in the city of Minneapolis during his term of office." He left office wondering if a city could truly be governed without an alliance with criminals.

THE ST. PAUL O'CONNOR SYSTEM

It took four months, 385 phonograph records of wire-tapped police conversations and three thousand typewritten pages of evidence to bring down the O'Connor system, which had given gangsters a safe haven in St. Paul. A few bad apples ruined it for the rest of the criminals. A new generation of gangsters like the Barker-Karpis Gang, "Machine Gun" Kelly and "Baby Face" Nelson deviated from the agreement of enjoying safe haven as long as they behaved while staying in town. The kidnappings of brewery heirs William Hamm Jr. and Edward Bremer, as well as robberies of mail delivery trucks and banks, signaled the end.

St. Paul, Minnesota, was first settled by three Irish soldiers who served at Fort Snelling and, through the assistance of Archbishop John Ireland, soon welcomed a mass immigration of Irish settlers. Ireland founded the Irish Catholic Colonization Association with progressive Catholic John Spaulding in the late 1800s, purchasing land to settle new Irish communities in Minnesota. Ireland worked with the railroads and the Minnesota state government to bring more than four thousand families from the slums of the East Coast and settled them on 400,000 acres of rural farmland. Although they were eventually outnumbered by Germans, it was the Irish who had the most political influence in St. Paul at the turn of the nineteenth century.

In 1855, at the tender age of one year, John J. O'Connor moved from Louisville, Kentucky, to St. Paul with his parents. His father was a well-heeled businessman who served on the St. Paul City Council. O'Connor grew up in St. Paul, taking a position with the Beaupre & Kelly accounting firm, where he worked for a decade. But O'Connor was looking for a more adventurous line of work and accepted a position as a detective with the City

of St. Paul, working his way up to the position of chief of detectives. He was removed from his position for four years, while Mayor Andrew Kiefer led the community. During those years, the city became infested with criminals.

O'Connor worked as a private detective while not on the police force. People said he had a twinkle in his eye and a jaw set for business. He compiled an extensive register of criminals in the St. Paul area. When Robert A. Smith was elected mayor in 1900, he appointed O'Connor chief of police, a position in which he served until 1912. It was as chief that O'Connor built his reputation as a clever, clear-thinking officer of the law, fighting crime with "organized intelligence." He created a system in which criminals were given safe haven in St. Paul as long as they checked in with the police upon their arrival and didn't commit any crimes while they were in the city. They were safe from extradition to other states, where court cases, fines and possible prison sentences awaited them.

A Hell of a Nice Guy

Dapper Dan Hogan was a St. Paul underworld character who straddled the divide between the law and the lawbreakers. The Federal Department of Justice considered him one of the most resourceful criminals in the nation. As owner of the Green Lantern Saloon on Wabasha Street, he carried out the work of the O'Connor system, keeping law officials abreast of which criminals were in the city and at the same time planning crimes and laundering dirty money.

Born in California about 1880, Hogan's first arrest was in Los Angeles in 1905 for breaking and entering, and he served a prison term in San

Dapper Dan Hogan

It felt very strange sneaking around Dan Hogan's yard. He was the man known as the "Smiling Peacekeeper" and enforcer of the O'Connor system. I stared at the cracked concrete of the garage apron, which led to the spot where his new Paige coup was parked when it blew up with Dan behind the wheel. No one knows for sure who planted the bomb under his floorboard, but people have their suspicions.

I'm from the farm. That should explain a few things—like why I thought I could just waltz into the Calvary Cemetery in St. Paul and locate the grave of St. Paul's Irish godfather without a single idea of where this icon of mobbery was buried. Some criminals are easy to find, like Kid Cann, who has a front-row grave with his brother, Yiddy Bloom. Hogan, on the other hand, eluded us.

My friends and fellow detectives, Penny and Melanie, joined forces with me to hunt down the grave of Dan Hogan. We started by driving through this old—and might I say, vast—cemetery. Around and around we drove, keeping our eyes peeled. See, this is where the country girl in me started to get a little worried. In outstate Minnesota, cemeteries are much smaller and easier to conduct a manhunt in. Penny had her Blackberry fired up, complete with Internet and GPS, and we still didn't have a clue how to track down our criminal.

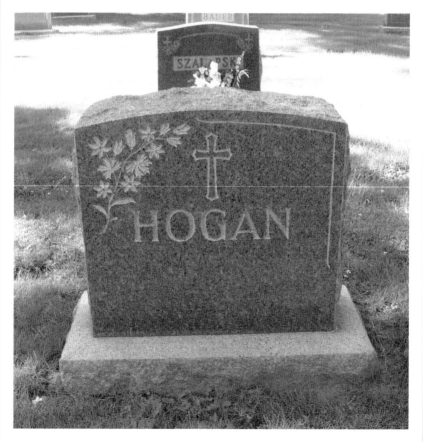

The Hogan family headstone in the Calvary Cemetery, St. Paul, Minnesota.

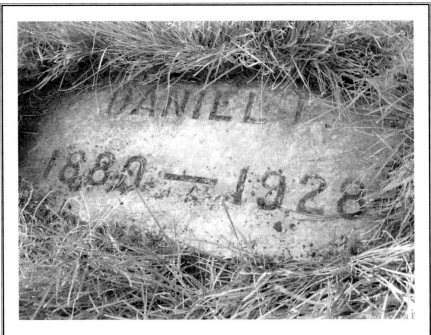

The grave marker for Daniel P. (Dapper Dan) Hogan, godfather of the Irish mob during Prohibition. Calvary Cemetery, St. Paul, Minnesota.

We finally gave up after traipsing through row after row of graves. Oh, it isn't that we weren't having a good time. It was a gorgeous day, and the names on the stones were like poetry: Sullivan, O'Hara, McCoy. There are an awful lot of Irish buried in St. Paul, but we didn't find Dan's stone until I went online and requested a map from Calvary Cemetery, which arrived in the mail later that week. Penny and I returned to the cemetery the following weekend, and sure enough, there was the Hogan family marker. But where was Dan?

I finally found his marker by digging my toe into the ground here and there until I felt something. Then I got on my hands and knees and started pulling at the grass. Soon I could see the dates of his birth and death at the hands of some weasely gangster. He died December 4, 1928.

It seems odd that these men, gangsters really, could now be so silent after wreaking havoc during the Prohibition years. Their graves are just like everyone else's. There's nothing special here. There are, however, the stories and disdain of their victims' progeny. And of course, the attention of the occasional writer in whose imagination these men are still very much alive.

—Minnesota Country Mouse

Quentin. Upon his release, he moved to the Midwest, where he plied his craft of robbing banks and stealing furs. Here in St. Paul, he became so entrenched with local law enforcement that they learned to fear him. The Department of Justice tried several times to convict him but failed to ever send him to prison.

Hogan was an expert at diffusing conflict and keeping feuds under control. He was known as a man whose word was as good as a gold bond. Yet in spite of his successful relationship with the police and underworld gangsters, he wasn't without enemies. There were those who resented his power within the city, over which he had a veritable stranglehold.

Hogan's death tells a great deal about how he lived. He has the honor of being one of the first people in the world to die from a car bomb explosion. About 11:30 on December 4, 1928, Hogan left his house at 1607 West Seventh Street in St. Paul and hopped into the Paige coupe parked in his garage. When he stepped on the gas and pushed the starter, there was an explosion that tore off his right foot completely, leaving his leg riddled with bomb fragments up to the knee. He also suffered a severe laceration to

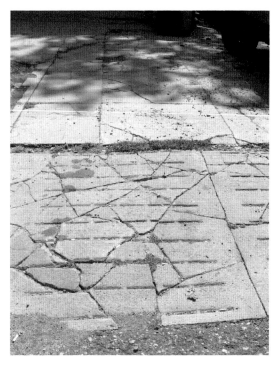

his right arm, lost his ring finger and had a deep cut above his right eye. Later, at the hospital, Hogan was completely baffled by the attack, claiming he could think of no enemy in the world who would do this to him.

His family and neighbors rushed to the scene, finding Hogan unconscious and bleeding profusely. Hogan's seventy-three-year-old father-in-law had intended to join Hogan for a trip to downtown St. Paul but returned to the house briefly to fetch a money order he had forgotten. They found the car with the floorboard blown to

The driveway that led to the garage where Dan Hogan was murdered by a car bomb.

Dan Hogan's
house in St. Paul,
Minnesota.

bits, the windows shattered, a hole blown in the roof of the car and the
steering wheel missing from its post. The hood of the engine was blown off,
but the engine itself was not ruined.

The police ambulance arrived to rush Hogan to the hospital. Meanwhile,
news of the explosion and Hogan's injuries traveled quickly, and soon the
hospital was filled with policemen, businessmen and racketeers offering to
donate blood to Hogan. Included in the group was Irish middleweight boxing
champion Mike O'Dowd. Hogan regained consciousness at the hospital; he
smiled at the surgeon, Dr. Arnold F. Plankers, and jokingly told him he'd
better do his best. He refused general anesthesia as his leg was amputated
in an attempt to save his life. Hogan rallied a bit following the operation but
eventually succumbed to his injuries at about nine o'clock that evening.

Police investigations were unable to pin the murder on anyone, but FBI
files point to "Harry Dutch," a Jewish gangster whose given name was Harry
Sawyer. Sawyer had been serving as Hogan's underboss, and Hogan owed
him $25,000 for bailing him out of prison several years earlier. Sawyer also
resented Hogan for cheating him out of earnings from the casino. Sawyer
took over the operations of the Green Lantern after Hogan's death.

A NEW KIND OF CRIMINAL IN TOWN

With Danny Hogan dead, there were concerns of retribution, but no criminal was ever fingered for the crime. The O'Connor system began falling apart after Hogan's demise. Sawyer took over where Hogan left off, arranging for criminals like the Barker-Karpis Gang, John Dillinger and Homer Van Meter to stay in the Twin Cities under protection of the law—all the while helping set up new criminal activity. In the 1930s, they became bolder, seeing big money in kidnappings. After enduring several high-profile kidnappings, the public reached its limit, and newspaper editor Howard Kahn, who worked for sixteen years on the *St. Paul Daily News*, called for a change. He brought in half a dozen Department of Justice operatives to prove malfeasance within the city's Police Department. There was a grand jury hearing, and a whitewashing of the results was aired over the local radio station, but it was enough to agitate voters into electing a reform candidate who was serious about cleaning up St. Paul.

The new public safety commissioner, Henry Warren, brought in a team of investigators who set up wiretaps in a back room at the police station and began an investigation. The recorded calls showed collusion between the police and bookmakers, brothels, slot machine owners and other criminals who were consistently tipped off when a raid was scheduled to take place. In return, the police profited from graft. In addition, the judges were also tipped off when a case was likely to be coming up.

The shake-up resulted in three detectives being dismissed and five police officers, including the chief, being put on probation. In addition, grand jury and bar association inquiries were begun, leaving anyone who had colluded with the cops in an anxious state. So there you have it: law enforcement in Minneapolis and St. Paul. It's not quite what you imagined, is it?

2

PROHIBITION

A Vain Sumptuary Law

The prohibition of alcohol in the United States, also known as the "Noble Experiment," was a *sumptuary law* put into effect in 1920 and lasting until 1933. Sumptuary laws attempt to regulate habits of consumption and, as a rule, fail to succeed. They have been used throughout history to regulate trade and, in extreme cases of ego, were used by the bourgeoisie to try to prevent commoners from dressing like nobility.

The focus of the temperance movement became more extreme, demanding complete abstinence from alcohol, a position that grew exponentially in popularity through the late 1800s and early 1900s. For a century, individuals fought the ill effects alcohol had on society through the efforts of the temperance movement. The original intention of the farmers in Connecticut, who banded together in 1789 to halt the production of liquor, was to advocate *levelness* rather than abstinence.

The quest for the prohibition of alcohol in the United States began manifesting in the 1820s, but the movement lacked leadership. There was, among a number of supporters of prohibition, a utopian mindset that banishing alcohol would cure all of life's woes. Romance would bounce back into lagging marriages, and employee attendance would spike at work.

Though attempts were made by men and women suffering from alcoholism to stop drinking, the underlying mental and emotional issues causing alcohol abuse went largely unaddressed until alcoholics Bill Wilson

Dumping beer from the August Schells Brewing Company, New Ulm, Minnesota. *Photo courtesy of Gary Revier, Redwood Falls, Minnesota.*

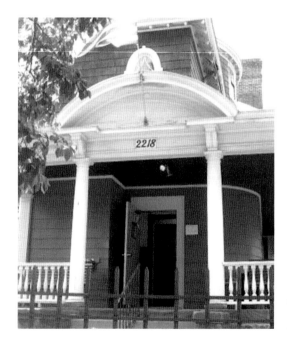

The entrance to 2218 First Avenue South in Minneapolis, Minnesota, the longest-running Alano or AA club in the world.

and Dr. Bob Smith joined forces in Akron, Ohio, in the 1930s to lay down the twelve steps and traditions of Alcoholics Anonymous (AA) to help those who wanted to stop drinking find a successful and spiritual remedy to their problem. Through working with other alcoholics and making it a point to do the next right thing, their group proves the power of being *for* sobriety rather than *against* drinking.

AA found its way to Minnesota when a suffering alcoholic named Pat Cronin came across the *Big Book*, written by Bill W. and Dr. Bob, in the Minneapolis Public Library. Through a series of events, Cronin not only managed to stay sober, but also, in March 1942, he and other alcoholics joined together to found the Alano Society, Inc., of Minneapolis, which has the distinction of being the longest-running AA club in the world. The club is located in a mansion at 2218 First Avenue South in Minneapolis.

THE VOLSTEAD ACT

H.R. 6810, Eighteenth Amendment to the United States Constitution

An Act to prohibit intoxicating beverages, and to regulate the manufacture, production, use, and sale of high-proof spirits for other than beverage purposes, and to ensure an ample supply of alcohol and promote its use in scientific research and in the development of fuel, dye, and other lawful industries.

Section 1. After one year from the ratification of this article the manufacture, sale, or transportation of intoxicating liquors within, the importation thereof into, or the exportation thereof from the United States and all territory subject to the jurisdiction thereof for beverage purposes is hereby prohibited.
Section 2. The Congress and the several States shall have concurrent power to enforce this article by appropriate legislation.
Section 3. This article shall be inoperative unless it shall have been ratified as an amendment to the Constitution by the legislatures of the several States, as provided in the Constitution, within seven years from the date of the submission hereof to the States by the Congress.

Conspicuously absent from the proposed amendment was the consumption of alcohol. With the Senate voting forty-seven to eight in favor

of the amendment on December 18, it was ready to be presented to the states for ratification. Ratification required thirty-six states voting in favor of implementing the amendment, and that was achieved on January 16, 1919. Minnesota voted in favor of Prohibition on January 17, 1919. Only Connecticut and Rhode Island rejected the amendment. The Volstead Act remained in effect until the passage of the Twenty-first Amendment, which repealed Prohibition in 1933. States were free to determine how they would enforce Prohibition.

Andrew J. Volstead

By all accounts Andrew Volstead, U.S. representative from the Seventh District in southwestern Minnesota, was a very agreeable, well-liked and notably stubborn man. Volstead was born in Kenyon, Minnesota, to Norwegian Americans Jon Einertson Vraalstad (Volstead) and Dorthea

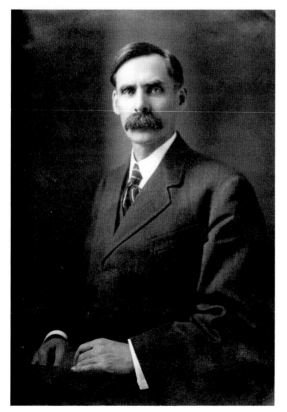

Andrew Volstead, chairman of the House Judiciary Committee and coauthor of the Eighteenth Amendment outlawing the production and sale of liquor from 1920 to 1933. *Photo courtesy of Dave Smiglewski, Granite Falls, Minnesota.*

The historic Andrew Volstead House in Granite Falls, Minnesota.

JOHN EDGAR HOOVER
DIRECTOR

Federal Bureau of Investigation
United States Department of Justice
Washington, D. C.

January 21, 1947

Mrs. Carl J. Lomen
Granite Falls, Minnesota

Dear Laura:

 When I heard the announcement over the radio this morning of the death of your father my heart was full of sympathy for you. I know how close you two were. However, you certainly can have consolation in the thought that he led a full and active life, having the confidence and good will of his fellow men.

 I did want you to know that my thoughts were with you at this trying time.

With deepest sympathy, I am

Sincerely,

Sympathy letter from FBI director J. Edgar Hoover to Laura Volstead Lommen upon the death of her father, Congressman Andrew Volstead of Granite Falls, Minnesota. *Photo courtesy of Bill Lavin and the Granite Falls Historical Society, Granite Falls, Minnesota.*

Mathea Lillo Volstead on October 31, 1860. He passed away on January 20, 1947. Upon his death, J. Edgar Hoover, head of the Federal Bureau of Investigation (FBI), sent a personal note to Volstead's daughter, Laura.

Volstead graduated from St. Olaf College in Northfield, Minnesota, and became a lawyer. He married Helen Mary Osleer Gilruth and settled in Granite Falls, along the Minnesota River, serving as mayor from 1900 to 1902. He was the Yellow Medicine County attorney for fourteen years and was elected to Congress as a Republican from 1903 to 1923, serving as chairman of the House Judiciary Committee from 1919 to 1923. It was Volstead's experience prosecuting bootleggers and operators of unlicensed saloons in several dry counties in Minnesota that made him especially well suited to put teeth in the Volstead Act.

There was a small hiccup during his run as congressman when Reverend Ole Juulson Kvale (sounds like quail) from Benson ran against Volstead as a Republican, accusing him of being an atheist. The public didn't take to such a notion, and by 1920, most of the voters who once knew Volstead were now deceased and no longer casting votes. He was defeated by Kvale.

Volstead, being no stranger to the laws on Minnesota's books, relied on an obscure law stating that if a candidate lies about or verbally abuses another candidate when talking to the electorate, he can be denied the nomination even if he or she is successful in the primaries. Volstead took his case to court, where his daughter, Laura, testified to Volstead's being a good, Christian man and a good father. Kvale was disqualified, and Volstead won the nomination and election.

In the following election, Kvale ran as an independent Farmer-Labor candidate. This time, Kvale won. After losing the election in 1922, Volstead returned to his law practice in Granite Falls, and in 1925, he was appointed as legal aid to the prohibitionist administrator in Minnesota, located in the post office building in St. Paul. On March 29, 1926, Volstead was featured on the cover of *Time* magazine.

The Eighteenth Amendment and the Volstead Act

As a small-town attorney from Granite Falls, Volstead conducted himself with dignity and style. And although he was not a teetotaler, he sponsored the legislation—the Eighteenth Amendment and the Volstead Act—that brought about one of the most divisive and turbulent eras of our country's

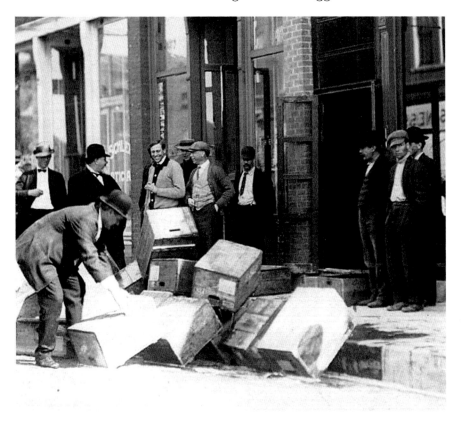

The "wets" on the right are not happy about dumping booze, and the "drys" on the left are laughing. *Photo courtesy of Gary Revier, Redwood Falls, Minnesota.*

history. Though the terms are typically used interchangeably, the Eighteenth Amendment prohibited the manufacture and sale of liquor, and the Volstead Act defined intoxicating liquor to that containing one-half of 1 percent alcohol, an amount considered by many to be an arbitrary figure.

The prohibition of liquor was a long time coming. On June 1, 1889, Minnesota implemented the Scheffer Law, requiring the police magistrate to sentence a man to prison for thirty days upon being found guilty of drunkenness for the third time. This ruling was the most severe in the country at that time. The desired effect was to punish the seller of alcohol. Prohibitionists were extremely active in the state, requiring liquor licenses in cities to cost $1,000 and in smaller communities, $500. Scheffer claimed he had no objections to people consuming liquor; he simply found it offensive to public morals and decency for one to be observed intoxicated. Unfortunately

for the courts, identifying a drunk three times in a row was hampered by the drunk's ability to think up a fictitious name each time he or she appeared before the court.

Under the Volstead Act, the economy changed. Individuals who had seen little chance of ever striking it rich before the Eighteenth Amendment took effect now found themselves in positions to do just that. Bellboys merely needed to have a little cash slipped to them to become a rich man's best friend, delivering bottles of hooch to hotel rooms. Taxi drivers no longer needed to sweat the miles they put on their meters; rather, they could simply drive their patrons to the closest bootleg outlet and make the purchase for them. Barbers could help a man on with his jacket while slipping a bottle into his pocket, scoring a fabulous tip. Men could finally make more money in one day than they had previously made in a week. Policemen and Internal Revenue employees, previously underpaid and overworked, finally had a means of putting money in the bank by merely winking and turning a blind eye to the bellboys, taxi drivers and barbers—for a small charge.

BOOTLEGGER'S SUPPER CLUB

1940 Eleventh Avenue, Granite Falls, Minnesota

Made from scratch food that's so good it should be illegal.
—Bootlegger's Supper Club motto

I can't believe how many times I've visited my friends Bill and Cindy Lavin in Granite Falls, Minnesota, without ever knowing there was an old speakeasy on the edge of town called Bootlegger's Supper Club (once known as Skunk Hollow). It was moved from the dense woods along the Minnesota River, near Wegdahl. The word that popped into my head when I walked in was "roadhouse." It is a tribute to the history of the 1920s. And it seems fitting that Granite Falls should be home to a speakeasy because it is the same little community that Congressman Andrew Volstead, author of the Volstead Act and the Eighteenth Amendment, hailed from. The ambience at Bootlegger's was down-home and friendly. I looked around the restaurant at the local clientele and thought, "Yup. These are my people." The food was good, and the servings were ample. I had a helping of torsk, swimming

in butter. My mom used to cook up a big batch of it for us kids and call it "poor man's lobster."

The food was good, and the company was great. But the next time I pull a toothpick out of my purse after a satisfying meal in Granite Falls, I'll know I need to join Bill outside while he has his after-dinner smoke. There is to be no picking in public. Cindy has her standards.

—Minnesota Country Mouse

Bootlegging was the first start-up industry in the United States that did not need protection from the government against foreign competition. As it stood, the demand for liquor outweighed the supply, and local bootleggers were not affected by imports. In fact, the industry didn't even need to worry about taxation because the general public had already paid its taxes for it through legitimate commerce.

WHEELERISM—DECEITFUL POLITICS

The bill introducing Prohibition was drafted by the "Dry Boss" Wayne Bidwell Wheeler, de facto leader of the Anti-Saloon League. Wheeler, a small, clerkish, bespectacled lawyer from Ohio and a graduate of Western Reserve University in Cleveland, is the man credited with creating "pressure politics," known today as *Wheelerism*. Pressure politics employs mass media and communication to convince politicians that the public is clamoring for a change. It often includes intimidation and threats toward politicians. Wheeler incited voters to vote for or against politicians based solely on their positions on the prohibition of liquor, working extensively through churches to build a powerful grass-roots movement. A politician's record as a fair and accomplished representative was completely discarded by the group, which focused on one issue only.

Wheeler was "born again" in 1893 during a sermon about temperance by Howard Hyde Russell, founder of the Anti-Saloon League. He immediately joined the group as its main promoter and lobbyist. Another leader in the fight for the prohibition of liquor was the well-known Ms. Frances Willard, leader of the Women's Christian Temperance Union, who had plenty of followers but watered down her message by also embracing additional interests, such as government-owned utilities and vegetarianism.

Wheeler and Russell joined forces, turning the Anti-Saloon League into a machine created to exact retribution on politicians who were not in support of the prohibition of alcohol. Wheeler traveled the state of Ohio, speaking at churches, sending telegrams and filing lawsuits. A former classmate called him a "locomotive in trousers." Wheeler's efforts were rewarded when the Anti-Saloon League managed to defeat all seventy legislators on whose backs the league had placed a target. With half of the new legislature pro-prohibition, the group was successful in passing legislation that put the control of saloons into the voters' hands.

In the days leading up to the vote on Prohibition, one of the most successful practitioners of pressure politics was William "Pussyfoot" Johnson. Johnson organized thirteen thousand business owners, who were supporters of Prohibition, to block telegraph wires to Congress for three days by sending telegraphs with the names of their employees signed as the senders. The ruse worked, successfully convincing representatives, even those opposed to the amendment, to vote for it.

The first senator to change his vote was Senator Warren Harding from Ohio, who admitted that although he was against the implementation of Prohibition, he voted in the manner he believed the majority of the people he represented wanted. Wheeler later bragged about the deceptive means he used to promote Prohibition.

Wheeler was taken to task by Representative John Philip Hill in June 1922 for stating that fifty members of the House, including Hill, were tied to liquor interests. Hill went on to point out that Wheeler himself was obstructing the will of the people with the help of money provided by gasoline, Coca-Cola and grape juice money when the people lobbied for the right to make beer with an alcohol content of 2.75 percent, along with the option to make cider and dandelion wine.

Legitimate businesses profiting from the ban on liquor weren't the only ones supporting Wheeler's cause. An entire culture of underworld gangsters and mob bosses was right there with him. The last thing organized crime wanted was for the Volstead Act to be done away with.

A Shortage of Liquor to Treat the Influenza Outbreak

Just a month after the implementation of the Eighteenth Amendment, problems were beginning to arise. State health commissioners began

warning of the possibility of a shortage of liquor to treat influenza, should it become an epidemic. Barely 10 percent of pharmacists had applied for permits to dispense liquor due to the complicated nature of the Volstead Act. As a result of the complaints, a joint resolution requiring special permits and reports, relative to the use of whisky for medicinal purposes, was suspended for ninety days. In addition, an amendment to the Volstead Act changed the amount of liquor that could be prescribed from one pint for a ten-day time period to a quart of spirituous liquor for fifteen days. The sale of the liquor gave the patient the right to transport his "medicine" without a permit.

When asked whether any medical opinions were sought during the crafting of the Volstead Act, Volstead said that no doctors were consulted, as some didn't believe liquor was medicine at all. Volstead had decided on a pint for every ten days himself, based on reason and the fact that some dry counties had settled on the pint for medicine, though he did not know if the amount was rooted in medical research.

The druggist would have to apply for a druggist's permit once a year but renew a purchase permit every three months. According to the law, the physician would need to write out three prescriptions. One was given to the patient to give to the druggist. The druggist would then mark the prescription canceled, write a record of the sale in a book and measure out the liquor.

The druggist would be carefully monitored and the liquor measured to make certain it was being used for prescriptions only. Heaven help him if an employee took a nip now and then. Although there was no penalty written into the law for the whiskey not measuring up, a druggist could be denied future permits if the prescription receipts and medicinal alcohol didn't match.

BEQUESTS OF LIQUOR

A reporter from the *New York Times* asked Volstead if liquor could be bequeathed from one individual to another. Volstead answered that although there was no prevision in the Volstead Act regarding bequeathing liquor, he imagined it would be okay as long as the liquor remained in the home and was used in the same manner as the bequeather had used it. If it were to be transported to another location, it would require a permit. He went on to say that if a man dies and leaves liquor to an heir in a will and it is transported to another location, then the one who inherits the liquor must use it for a non-beverage, medicinal purpose. Got that?

Accusations of Legislative Bribery

In June 1922, Representative G.H. Tinkham, a Republican from Massachusetts, came across a published statement that said representatives of eleven Anti-Saloon State Leagues spent $100,000 to $150,000 on anti-liquor interests promoting the Prohibition Amendment and promised Volstead their support in the autumn campaign. Tinkham took his grievances to the House floor:

Here, again we have the outrageous situation about which I have protested. Here, again we have the Anti-Saloon League, dependent upon the Representative of the Seventh Minnesota District for its intended further restrictions of the personal liberties of our people, proposing to purchase that preferential treatment it has received heretofore by supporting with money a campaign for re-election of the Representative from the Seventh Minnesota District.

To all intents and purposes, this is legislative bribery. If we are going to have prohibition let us prohibit this insidious evil more inimical to the foundations of our Government than the abuse of liquor ever was.

Before this congress adjourns, it should place upon the statute books an act I have introduced making it a crime for any person, corporation, association or organization interested in passage or repeal of any legislation, of whatever character to purchase it by spending money for the election of men who will favor their selfish interests or their particular or peculiar legislative ideas. When Mr. Wheeler appeared before the House Judiciary Committee at the present session asking for more drastic restrictions, he knew he had broken the law.

He was a legislative corruptionist. I challenge him to sue me for libel, and I promise to waive any immunity I have as a member of Congress, if what I have just stated is untrue. He dare not face a court of law where he will be compelled to tell the truth. His very presence in the Capitol is an offense against decency. With him there is the incarnation of invisible government and the rule of the power of money.

Wayne B. Wheeler has systematically and on a wholesale plan, subsidized in the way indicated in the case of the Representative from Minnesota, many members of Congress and concealed the facts by not complying with the act of June 25th, 1910, until the election of 1920.

Wheeler managed to keep the finances of the Anti-Saloon League quiet by not reporting receipts and expenditures long after the law required

them to be reported. As the clerk read the resolution on the House floor, lawmakers began hooting and shouting him down. At the time, the House was composed almost completely of representatives elected by the Anti-Saloon League. Republican representative James Mann, from Illinois, moved that the resolution be laid upon the table, preventing Tinkham from taking the floor. Upon further shouting from members of the House, the resolution was removed and expunged from the record. Following the debate, Volstead offered the following remarks:

> *I am very much gratified at the reception the House gave Mr. Tinkham, in which he sought to have me removed from the Judiciary Committee because the anti-saloon forces supported me in the last election. Only two members, both from New York, were willing to follow his lead. The House did not only kill the resolution, but promptly, without debate, expunged it from the record.*
>
> *I have never shirked from a fair fight but have always tried to treat my opponents fairly, and, as a rule, I have in turn, received fair treatment— although the fight over prohibition has at times been very bitter. The member from Massachusetts who poses as one of the prominent leaders of the Wets is the only one in the House who has broken the rules of civilized warfare.*

This magic bullet of prohibition, which was going to create the United States of Utopia, was a problem from the start. In an open letter to the editor of the *New York Times* on June 28, 1923, attorney Everett P. Wheeler described some of the trouble with the law:

> *Our first objection to it is that it gives a false definition of intoxicating liquor. Our second objection to it was that it was put through Congress by two vicious deals. One has been fully exposed by the National Civil League. The bill exempts from law all persons appointed under it. This enables political members of Congress practically to control the appointments to enforce the law. Many men who have been appointed for political reasons are entirely unfit. The result is graft, the enrichment of officials and violation of laws. The other is the section which exempts farmers from of the act in their manufacture of cider and grape juice. This privilege to them won many votes. But it is a source of dissatisfaction for the dwellers in cities. Why not let them buy the cider which the farmer is allowed to make?*
>
> *…We do not agree with Governor Pinchot that prohibition will raise the happiness and welfare of our people. On the contrary, we think it is turning*

us into a nation of cheats and hypocrites. It is essentially Mohammedan. The Mohammedan religion is based on the idea that merit of the believer consists in outward observances. Christianity teaches us the reverse. St. Paul tells us that "The Kingdom of God is not meat and drink."

The advocates of prohibition talk and act as if all the virtues were summed up in the strict observance of the rules laid down by the Volstead Act. In the recent hearings before Governor Smith of New York, they claim that the whole force of the State of New York should be employed to enforce the Volstead Act. To them this is much more important than the laws against adultery, robbery and perjury. These crimes were forbidden by God Himself on Mount Sinai. Our police are now free to enforce these laws.

VOLSTEAD RAVES ABOUT THE SUCCESS OF THE AMENDMENT

On August 15, 1923, Volstead was on his way to Bremen, Germany, with his daughter, Laura, to attend the International Congress Against Alcohol to tell the world how successful the dry laws in the United States had been. Did he really believe it? In an interview conducted by the *New York Times* before Volstead's trip, Volstead admitted that before Prohibition, he drank liquor occasionally. He wouldn't, however, comment on whether he had consumed liquor with over one-half of 1 percent alcohol content since Prohibition became the law of the land.

He told the interviewer that he had just spent two days in New York and was pleased to announce that all saloons were locked up tight, and even more impressive, there were no longer back parlors serving liquor. He said the police arrested anyone who looked like they were under the influence and that hospitals were free from all alcoholic cases—and that included Bellevue's psychopathic ward. He announced that the police magistrates had so little to do that they could barely figure out what to do with all their free time.

When one of the reporters suggested to Volstead that the streets were bare because people were bootlegging their own liquor, Volstead answered, "Rats! Nothing of the sort. They are not that kind of people." He went on to say that there hadn't been a case of delirium tremens in Chicago for two years. His hackles were raised again when a reporter told him that government officials, bankers, merchants and judges were known to take a drink. "Rats!" he exclaimed to the reporter. "What if they do? There is no harm in a man's taking a drink if it is done in a proper way. Besides, those people bought their stocks before Prohibition came into force."

Volstead didn't stop there. He went on to announce that the workingman, without liquor, was far more efficient, taking a keener delight in his daily toil than before, when he was subjected to the deadly lure of beer. He and Laura then went to his stateroom on the ship and locked the door, avoiding any photographs. Although Volstead was not conducting his business under the influence of alcohol, he must surely have been under the influence of Wheeler.

On November 6, 1925, Volstead addressed the Anti-Saloon League at a convention in Chicago, declaring he wanted some of the "good people" in the country revealed as being in the "bootlegger class," and went on to argue that the Dry Law had saved millions. He encouraged his listeners to enforce sentences of ninety days' imprisonment for the purchase of illicit liquor for a first offence and up to two years in prison for the second.

He went on to declare that the judges who imposed a fine were little better than the bootlegger, stating that a fine was nothing more than a license to be drunk.

Unintended Consequences

While Volstead continued championing Prohibition, others were looking at the unintended consequences of trying to impose one's sense of morality on the unwilling. Arguments were being brought before Congress telling a completely different story. The Reverend Dr. Roland Sawyer of the Massachusetts legislature reported that the Volstead Act was driving alcohol *into* the home, undoing nearly a century's worth of temperance.

Former judge Harry S. Priest of Missouri railed against the excessive amount of money used to bring about the Eighteenth Amendment and the actions taken by Wheeler when he threatened that congressmen and senators would not be returned to their districts if they did not vote dry. He went on to claim that people, as a whole, found the law obnoxious and were using every conceivable type of ingenuity to evade it: "It is an inquisitional law which wears as its badge morality; a law that discriminates between rich and poor."

Dr. P.J. Vorbeck testified, presenting data showing that raising the alcohol content of beer to 2.75 percent would serve the needs of the human body. He showed evidence that the human body contains, as some of its necessary constituents, the elements provided in 2.75 percent beer. He allowed that the amount would be intoxicating, but at the same time, it would serve the needs of the human body.

In a dramatic presentation, Dr. James Whitney Hall of Chicago, chairman of the Lunacy Commission of Cook County, placed a variety of bottles containing liquid of different colors on the table before the House Judiciary Committee, explaining that the homemade liquor was poison. He showed the committee a copper flask, in which bootleg liquor was held, that could be purchased for twenty-five cents, explaining the dangers of drinking alcohol from a copper container. He concluded his presentation by telling the committee that insanity caused by the consumption of bootleg, poisonous alcohol had increased 1,000 percent since World War I.

Dr. W.F. Lorenze, professor of nerves and mental diseases at the University of Wisconsin, advised the group that, since the Volstead Act was instated, the age of alcoholic insanity dropped from between thirty-nine and forty-five years down to between twenty-two and twenty-five. He added that of the 209 ex-servicemen currently serving time in the penal institutions in Wisconsin, 31 percent were there due to crimes related to alcoholism. He testified that the population of individuals in mental institutions had risen 20 percent since implementation of the Volstead Act.

Charles A. Windle, representing the Illinois Division of the Association Opposed to Prohibition, called Prohibition a costly experiment. He said that increases in bank deposits had been due to a larger volume of exports and an increase of 100 percent in wages during the previous years. In addition, banks and burglaries were also largely responsible for higher deposits due to moonshiners, bootleggers, rumrunners and hijackers.

Before Prohibition, grape growers received $45,000,000 annually, but since Prohibition began, that amount had grown to $315,000,000 per year; grape growers were happy for Prohibition's failure to prevent citizens from consuming alcohol. Windle estimated that the entire cost of Prohibition for the first four years came to $6,052,000,000, or more than the entire British war debt.

The Reverend Dr. Sawyer bemoaned the fact that although efforts had been made since 1840 to drive liquor out of homes, children now saw their mothers and fathers making whiskey at home, discussing it around the dinner table and getting a big kick out of it. He suggested that Prohibition had created a new criminal class and expressed frustration for a country dictated by fanatical elements. He begged the committee to let the citizens of the United States use their common sense, accusing the Anti-Saloon League of not reading history correctly and bringing on a "fools paradise."

Threat of a Civil War

It is not uncommon for the masses to revolt when their liberties are threatened, and after a decade of Prohibition and mayhem, Minnesotans were weary. A pivotal moment came about in May 1929, when candy store owner Henry Virkula from Big Falls, Minnesota, drove his wife and two children for a visit to International Falls near the Canadian border. They returned in the evening, driving along the public highway as the sky grew dark. Virkula stopped the car to light a cigarette and then turned onto a side road in a wooded area and headed toward home. The children slept soundly in the backseat.

Suddenly, two men jumped in front of the car holding a sign claiming they were U.S. customs agents and commanded them to stop. Virkula slammed on his brakes, but before the car could come to a complete stop, a round of bullets was fired through the back window, missing the sleeping children and Virkula's wife but catching Virkula in the back of the neck with a slug. The car plunged into a ditch, coming to a halt, and the children awoke, crying. When Mrs. Virkula hysterically advised twenty-four-year-old U.S. border patrolman Emmet J. White that he had just killed her husband, he replied, "Sorry lady, but I done my duty." His defense was that the car hadn't stopped when his partner, Patrolman Emil Servine, held up the sign.

Patrolman White was arrested and placed in the International Falls jail, charged initially with manslaughter and later with murder. His bail was set at $5,000, which no one provided.

Enough was enough for residents in northern Minnesota, who had more than their share of illegal activity with illicit liquor being smuggled across the U.S.-Canadian border. The community of Big Falls was livid with anger and sick to death of the laws that had created the kind environment in which an innocent family could be ambushed by law enforcement officers who had taken a pledge to defend them. They issued a letter to President Hoover begging for change. The community wrote of its fear and despair, pleading with the president and the United States Congress: "For God's sake, help us!"

3

BOOM!

At a glance, the 1920s were defined by a decadent and excessive lifestyle in the midst of Prohibition. Across the country, women were painting their lips to look like little rosebuds, imitating F. Scott Fitzgerald's trend-setting wife, Zelda, as they met their flask-carrying dates for a night on the town. These young people were referred to as the "lost generation," due to so many young men having had to serve in World War I rather than experiencing normal young adulthood. Young women were defiant,

World War I soldiers leaving for Fort Deming. *Photo courtesy of Gary Revier, Redwood Falls, Minnesota.*

forgetting their place and aiming for the right to vote. They treated sexual escapades with the same casual attitude of their male counterparts and forced the country to move in a new direction.

Let's Follow the Money

The history of the 1920s and '30s is dominated by banks, money and the economy, going from excess in the '20s to bust in the '30s. I have always found the causes of the Wall Street Crash of 1929 and the Great Depression of the 1930s a historical mystery. This won't be easy, but I'm going to see if I can put the puzzle pieces in place.

In 1776, the framers of the Constitution created the groundwork for the U.S. government to print and regulate money. The first bank in the United States was the Bank of North America, established in Philadelphia in 1781. Ten years later, the government chartered the First Bank of the United States to act as a fiscal agent of the government and engage in commercial banking.

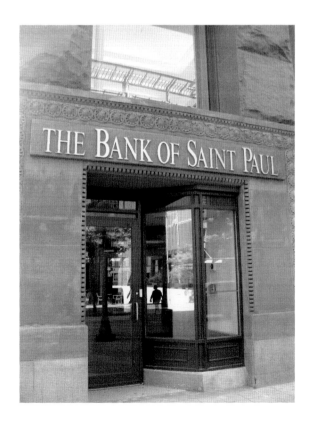

The Bank of St. Paul building, built in 1889, St. Paul, Minnesota.

Wildcat Banks

Between 1837 and 1885, a wave of "free banks" followed on the heels of New York, adopting the Free Banking Act and making it possible for anyone, under a state's charter, to issue currency completely free of regulation by the federal government. Any individual, or group of individuals, who met the state's requirements could open a bank.

Free banks, also known as "wildcat banks," were immediately established in Michigan, Georgia and New York.

Wildcat banking is a term believed to have been derived from the Michigan bank note featuring the image of a wildcat. Upon the bank's failure, the notes of little or no value became known as "wildcat currency."

Bank notes were issued based on the bank's assets (generally government bonds) and could be handed from one individual to another, similar to Federal Reserve notes (dollar bills). When a note was issued, it functioned as a contract to be fulfilled by the issuing bank. At times, when individuals attempted to redeem the notes, the banks no longer had the means to pay the owner of the notes. Since it was difficult to tell the difference between a real bank note and a counterfeit imposter, U.S. president Andrew Jackson required real estate transactions to be paid for in gold or silver coins. After 1849, wildcat banks spread west, garnering a larger market share. Free banking ended in 1865, when the federal government imposed taxes on bank notes, driving wildcat banks out of business.

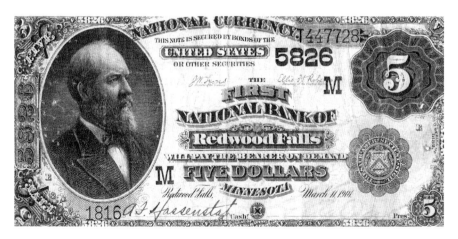

The front side of a pre–Federal Reserve bank note, dated March 11, 1901, from the First National Bank of Redwood Falls, Minnesota. Signed by A.F. Hassenstab. *Image from the late Evelyn Walters.*

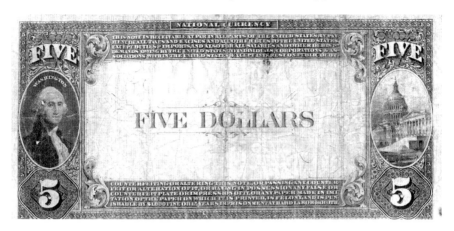

The backside of a bank note from 1901. *Image from the late Evelyn Walters.*

G. Edward Griffin, author of the book *The Creature from Jekyll Island*, suggests that state banks were driven out of business because large New York banks, often co-owned by foreign entities, were losing their power and making up a progressively smaller share of the banking industry in the United States. The demise of state banks allowed them to win back a huge market share.

The National Banking Act of 1864 required banks to buy government bonds, instead of gold, to back their bank notes and allowed them to buy and sell obligations of the government, municipalities and corporations. They were, however, unable to deal in stocks. The banks eventually began advising clients about investments and began selling bonds on commission. Both activities fell into the loophole of "incidental" activities and earned the banks additional income through commissions. The role of the National Bank, as prescribed by Congress, was to provide funds for short-term, self-liquidating loans—say, for business inventory.

BIRTH OF THE FEDERAL RESERVE, 1913

This is a fascinating story and one that we are not taught in school. The Federal Reserve is, in fact, a *privately* held corporation, conceived by its wealthy founders—Paul Warburg, representative of the Rothschild banking dynasty in England and France; Senator Nelson Aldrich, Republican whip

and chairman of the National Monetary Commission; Frank Vanderlip, representative of William Rockefeller and president of the National City Bank of New York; Benjamin Strong, head of the J.P. Morgan Trust Company; Henry P. Davison, senior partner at J.P. Morgan Trust; and Charles D. Norton, president of J.P. Morgan's First National Bank of New York—during a duck hunting trip to J.P. Morgan's Jekyll Island, in Georgia, in December 1910.

The idea was to create a central bank with twelve regional reserve banks, including one in Minneapolis, Minnesota. The initial plan was to have a board of commercial bankers overseeing the regional banks, but Democrats in Congress blocked it. The plan was later reintroduced in 1913 by Democrat Carter Glass, from Virginia, as the Federal Reserve Act, only Glass replaced the concept of commercial bankers as overseers with a board of bureaucrats. The wealthy international bankers now had a "central command post" from which to control our economy and print money, in complete contrast to what was stated in the Constitution. The people of the United States would now pay interest on every dime the Federal Reserve produced for us to spend.

In 1848, the *Communist Manifesto* used the very same framework for its recommended banking system: "Centralization of credit in the banks of the state, by means of a national bank with state capital and an exclusive monopoly."

Minnesota's Charles A. Lindbergh Sr. forewarned, in 1913, "When the President signs this bill, the invisible government of the monetary power will be legalized…the worst legislative crime of the ages is perpetrated by this banking and currency bill."

Woodrow Wilson signed into effect the Federal Reserve Act on December 23, 1913, while Congress was not in session. As a result, our society, our behavior and our economy would now be influenced by a small group of men in a very powerful position. The icing on the cake was the part of the Federal Reserve Act that prevented this private business from having to pay taxes—an exemption that continues to this day.

The 1913 Federal Reserve Act removed the barriers from national banks, allowing them to exercise trust powers and freeing them up to act as trustees, executors, administrators, receivers and registrars of stocks and bonds. Their greatest competition in the 1920s were fast-growing trust companies with the ability to combine banking and additional fiduciary services, including the buying and selling of investment securities. This part is important because the purchasing of securities is what helped lead to the crash of the 1930s.

Income Tax Becomes Law

In his article entitled "The Income Tax," published in the May 1913 *Saturday Evening Post*, Benton McMillin, former governor of Tennessee, justified the creation of the income tax:

The income-tax question is one that will not down. For the best of reasons this is true. Way down in the hearts of the masses of mankind there lurks a strong sense of justice, on which is founded the opinion that vast accumulations of wealth in the hands of individuals or corporations should help to support the Government under which they are acquired, by which they are protected and without which they would vanish.

And why not? Why tax the widow's mite and the orphan's bread, and not tax these accumulations? Why lay tribute on what we eat and wear, and leave untaxed millions in the hands of those who can never personally consume it, and with whom it is surplus?

If there ever was a time when the concentrated wealth of the land should bear its share of our enormous expenses of government it is now.

There is a necessity of an income tax now that did not exist when our Government was conducted economically. In all the history of the Government of the United States there never was such an era of prodigality as that on which we have fallen. The Prodigal Son in his most prodigal day was parsimonious when compared with some exhibitions of extravagance that have characterized our Government in recent times.

There are reasons, besides its intrinsic justice, for the enactment of this tax. By this means the revenues can be increased or diminished by increasing or reducing the rate on income without materially disturbing business. Not so with tariff taxes, where a general revision, whether upward or downward, produces more or less business disturbances until the manufacturers, merchants and people adjust themselves to such change.

Again, in case of sudden war it is grossly unjust to let accumulated wealth, yielding great income, escape the increased burdens caused thereby and place all on consumption, stamps, and so on, where no man pays in proportion to his wealth.

Strangely enough, immediately after the destruction of the income tax by the Supreme Court's decision of five to four we were in the midst of our first foreign war for half a century, and had to send troops beyond the seas to the opposite side of the globe. By reason of this, and that wanton recklessness in expenditure which is too common with our National Government in recent

years, Federal expenses have gone far beyond the billion-dollar mark; and consumption—not accumulations—has had to bear the heavy load.

Before 1913, the United States relied heavily on taxes paid by foreign countries for products imported into the United States and from taxes paid on the sale of liquor and tobacco. In 1912, those taxes made up two-thirds of our federal revenue. In 1913, the Sixteenth Amendment made income tax permanent within our tax structure, going into effect in 1914. Less than 2 percent of the population was required to pay taxes. The first $3,000 was exempt from taxes, and incomes up to $20,000 were taxed at 1 percent. Incomes above $500,000 paid 7 percent. In 1913, the majority of incomes were less than $1,000.

Taxation was raised to unprecedented levels in 1917 with the War Revenue Act, in anticipation of the United States' entry into World War I. The increase in revenue paid for two-thirds of the cost of the war. Once the war ended, the national debt dropped, and taxes were lowered.

Prohibition Means Lost Tax Revenue

Income tax helped make up a portion of the loss of liquor taxes, until the onset of the Great Depression, when incomes dropped dramatically. Once it was established that revenue could be collected yearly from the income of the citizens of the United States, politicians could engage in the debate about whether citizens should be allowed to consume "John Barleycorn" and gain the support of the temperance movement voters. Income tax paved the way for the serious consideration and eventual crafting of the Eighteenth Amendment prohibiting the sale and consumption of liquor in our great country. The battle between "wets" and "drys" had begun.

The last year before the prohibition of liquor went into effect, the government collected $482,000,000 in taxes from liquor traffic. The figure was impressive, particularly because thirty-three of the states were dry or had some dry counties in them. Ten years later, in 1930, that figure shrank to just $10,000,000. The beauty of liquor taxes was that they were consistent, with little fluctuation. Liquor taxes before Prohibition added up to over twice the amount of taxes collected from customs receipts of imported goods and far more than the $207,000,000 collected from the sale of tobacco.

The wet states during the peak years of tax revenue were New York, New Jersey, Illinois, Massachusetts, Rhode Island, Connecticut, California, Delaware, Louisiana, Maryland, Minnesota, Missouri, Pennsylvania, Vermont and Wisconsin.

The Boom of the 1920s

The 1920s started out rocky as the economy adjusted to the end of World War I, and a flood of returning troops raised the unemployment rate. President Warren Harding was faced with almost 12 percent unemployment, and the Gross National Product had declined 17 percent. His remedy was to cut taxes for all income groups (they had been raised to an unprecedented level to pay for the war) and government spending. (With World War I out of the way, defence spending dropped from almost $12 billion in 1919 to just over $2 billion in 1920. Education, welfare and healthcare spending all increased slightly.) Manufacturing could get back on its feet, providing products for domestic use rather than for the military. What President Harding chose not to contend with was economic manipulation by the Federal Reserve. By 1923, unemployment was down to 2.4 percent.

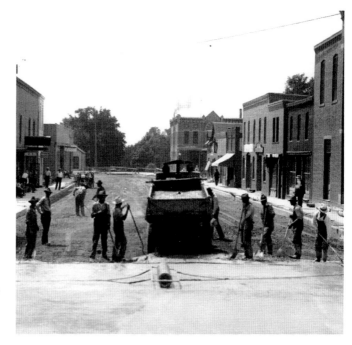

Paving a street during the boom of the 1920s. *Photo courtesy of Gary Revier, Redwood Falls, Minnesota.*

The United States saw growing economic ties with Europe. Wall Street invested heavily in European debt to assist in rebuilding its economies after World War I. Speculation by financial institutions was high, with celebrity neoclassical economist and eugenicist Irving Fischer naively asserting shortly before the 1929 Black Thursday stock market crash:

> *Stock prices have reached what looks like a permanently high plateau. I do not feel that there will soon, if ever, be a fifty or sixty point break below present levels…I expect to see the stock market a good deal higher than it is today within a few months.*

Irving consequently lost a fortune in the crash. I have decided that economists are like weathermen; they give it their best shot.

Harding served from 1921 to 1923, when he suddenly died of a heart attack. He was extremely popular at the time of his death, but his popularity was soon destroyed by the Teapot Dome Scandal, in which, by executive order, Harding passed the control of the U.S. Navy petroleum reserves in Wyoming and California to the Department of the Interior, which then leased the reserves, without competitive bidding, to Harry F. Sinclair of Sinclair Oil. In addition, an oil field in California was leased to Edward Doheny, founder of the Pan American Petroleum and Transport Company, which was later sold to Standard Oil. The reserves were intended for use by the U.S. Navy.

It appears the Federal Reserve (Fed) felt that the adjustment to the economy during 1920 was too severe, and it was chomping at the bit to use its new powers to influence the economy. The Fed created a new open market policy in 1923, basing the value of money on bonds and investments and freeing the Fed from working within the framework of the gold standard. The Fed lowered the required reserve that banks held, making it possible for them to stretch the number of loans they made but leaving them with a smaller reserve in the event that those easy loans went bad.

The citizens of the United States took advantage of cheap loans, starting businesses, building homes and investing in the stock market on easy money. The economy was off to a rousing start. Employers demanded higher productivity from their employees, without increasing employee pay. Instead, they invested their profits in additional factory space and in the stock market. Increasing production, without increasing wages, which would allow those additional products to be purchased, created an imbalance between the production of goods and the ability of consumers to purchase them.

We Are Affected by Germany's War Debt

Across the ocean, the Treaty of Versailles, penned by representatives of Britain, France and the United States, was signed on June 28, 1919, at the end of World War I, leaving Germany with a $269 billion debt to be paid in land and cash, along with the acceptance of guilt for the conflict. Paying the huge debt to the Allied powers required innovative thinking. The solution was determined by Charles G. Dawes, an American banker whose notion was to get big international banks to borrow money from small western investors by selling bonds and for Germany to secure foreign loans. The bonds were sold from 1924 to 1930, raising $110,000,000, the equivalent of $1.2 billion at today's rate.

Despite investors being told that the bonds were guaranteed, and President Coolidge encouraging U.S. citizens to purchase them, the bonds failed. In 1933, Hitler ordered that none of the bonds be paid and then began buying them back for pennies on the dollar, leaving only the Nazis—and those earning commissions on the sales of the bonds—with money in their pockets.

The selling of war bonds during World War I began changing the way people thought about their savings. The public became accustomed to the idea of investing money in securities. Banks saw great success with the sale of war bonds and looked toward investments for profits on their balance sheets. The *Minneapolis Journal* wrote an article about the Minneapolis Federal Reserve president's attitude toward the issue and purchase of Liberty Bonds and the question of patriotism:

> *An inner committee, designated by E. W. Decker as the "big stick" committee, is to check up on contributions and call parsimonious givers to account.*
>
> *"What is this I hear about slackers?" Mr. Decker rose to demand. "Well, we're preparing to use the big stick. Any business house or individual who in the opinion of the solicitor is shirking his duty should be reported to the Executive Committee."*

Minnesota congressman Charles A. Lindbergh Sr., who served from 1907 to 1917, representing the Sixth Congressional District, defended his constituents in his book, *Why Is Your Country at War?* The book was banned and burned, and the printing plates destroyed:

> *It has indeed been humiliating to the American people to see how the wealth grabbers, owners of the "big press," actually attempt by scurrilous editorials*

and specially prepared articles, to drive the people as if we were a lot of cattle, to buy bonds, subscribe to the Red Cross, to register for conscription and all other things. The people will do their duty without being hectored in advance by the "big interests" press. What right, anyway, has the "big press" to heckle the people as if we really belonged to the wealth grabbers and were their chattel property?

It was the demand of wealth that we prepare a great Navy and a great Army in order to enforce the existing political and economic system not only upon ourselves, but upon all the world—present and future. It required that we should impress into the service of war, every available man and woman at nominal pay for their time. What did wealth offer in return? It offered to sell copper to the Government for 16 cents a pound when it cost only 7 cents. It offered to loan money to the Government at 3½ percent provided the government would raise the interest if later bonds should draw more. It offered other things provided always there was a profit to wealth. But it protested against big incomes being taxed much to support the war for which its system is responsible.

Eventually, the need for short-term loans diminished as companies learned to manage their inventories in a more efficient manner, preferring to use their retained earnings and new stock issues to pay for inventory. Near the end of the 1920s, the largest corporations in the country did not have outstanding loans, making it very difficult for banks to raise income on loan interest payments. Banks began leaning heavily on the sales of securities, commissions from insurance premiums, trust operations, the fees from real estate mortgages and bonds. With their profits from conventional loans falling, banks moved into providing more financial services and investment opportunities. From 1921 to 1928, trust funds, in which the legal title to property is held by one party for the benefit of another, grew exponentially.

THE BIRTH OF DERIVATIVES

Small rural banks occasionally found themselves with more mortgages than they cared to hold. The First National Bank of Coos Bay in Marshfield, Oregon, found a solution. It found that many of its customers were interested in investing, but it was difficult for them to find an investment the right size for them. With the bank's newfound trust department and fiduciary powers, the First National Bank began to break up the mortgages into smaller

parts, fitting the size of the investment to the amount of investment the customer wanted to make. The bank would hold the original mortgage but sell certificates of interest. If the mortgage was too risky, it might be pooled with other mortgages to lower the risk.

In 1927, the McFadden Act made it possible for national banks to sell investment securities. The number of banks peaked in 1931, with 237 banks handling investments for their customers, mostly in large and medium-sized communities. Banks in smaller communities typically only engaged in investment advising or executed a customer's order upon request.

Banks began buying interest in other banks. The First National Bank Stock Corporation of Minneapolis controlled roughly one hundred banks, with its affiliate, First Securities Corporation, handling all the bond business for the banks. This created competition and cause for worry among investment bankers, leaving them at a disadvantage because if a bank thought a particular stock would be easy to resell, it could use its own reserves to purchase a large amount for resale to investors.

In the end, it was commercial banks' speculation in the stock market that carried a huge portion of the blame for the financial crash. They were accused of becoming greedy and taking on unreasonable risks. The practice of giving risky loans to unsound businesses in which the bank was already invested became common practice. Adding insult to injury, these same banks encouraged their customers to invest in the same shaky companies the bank was financing.

While the economy was heating up due to easy money and risky loans, factories were churning out goods at a higher rate than consumers demanded. Individuals were able to borrow money to purchase stock without collateral—the perceived value of the stock fulfilled that requirement. There was a frenzy of home building, and families spent beyond their means. A housing bubble grew throughout the 1920s. It was good times with zero inflation and high employment. With the economy heating up and growing too quickly, an adjustment was inevitable. The lights came on on Wall Street, with the creditors shouting for "last call."

4
THE FOSHAY TOWER
A Monument to Flimflammery

One of most perfect examples of the boom and bust story and of white collar crime of the 1920s is recorded in Minnesota's history courtesy of Wilbur B. Foshay and his partner, Henry H. Henley. We remember Foshay for the skyscraper he built in Minneapolis, but he perfectly illustrates the risk of loose regulations in the financial industry, which created a huge financial bubble. A portly, well-liked gentleman, Foshay had the heart of an artist, the gumption of an industrialist and the cunning of a flimflam man. Foshay, whose grandfather served as chief of police under Napoleon Bonaparte, was originally from Ossining, New York. As a young man there, he studied art, electricity and engineering at the Cooper Institute and the Massachusetts Technical Institute in Boston. He spent six years working for the United Gas Improvement Company in Tarrytown after completing a four-year stint with New York Central Railroad Company. He held a number of positions in the public utilities field throughout the country and purchased his first utility company in Hutchison, Kansas. He arrived in Minnesota in 1914, at the age of thirty-six, and built a financial house of cards from his offices at 828–30 Second Avenue South in Minneapolis.

As a resident of Minneapolis, Foshay and his wife, Leota Hutchinson Foshay, and their children, William and Julianne, attended St. Mark's Episcopal Church in the Loring Park neighborhood. Foshay was also a member of the Minneapolis Athletic Club, the Lafayette Club and the Benevolent Order of the Elks and Masonic fraternity. Foshay was a keen supporter of the Boy Scouts of America.

W Minneapolis Hotel — The Foshay

821 Marquette Avenue in Minneapolis, Minnesota

My friend Melanie and I went on our first field trip to the Foshay Tower in Minneapolis, the tallest building west of the Mississippi until 1971, when the IDS building was built. Somehow, in our formative years, we missed out on bumping along on a crowded school bus from southwestern Minnesota to the Twin Cities to see this mighty monument of prosperity, doom and rebirth.

I was on a mission. While researching information for my upcoming book, I came across a court appeal for a tax evasion committed by gangster Leon Gleckman back in the 1930s. Gleckman ran his empire from the third floor of the St. Paul Hotel. In the appeal, I saw mentioned the Foshay Bank, located in St. Paul. This was news to me, and I was determined to find out more. I had always assumed the wildly successful and wealthy Wilbur Foshay must surely have had an acquaintance with the wildly successful and wealthy scoundrel Gleckman.

We were met at the front desk of the Foshay, now the W Minneapolis Hotel, by art director Jennifer Phelps, who graciously escorted us to the Foshay Museum. We admired the original art deco ceilings and elevator doors. The three of us began scouring documents for something that would confirm that Foshay had a bank in St. Paul. The photos were wonderful, and the relics inspiring, but there was nothing about a bank. I had despaired of making a confirmation—and then there it was. The Holy Grail.

It was an old ink well engraved with the words "W.B. Foshay Co. Investment Bankers, Pioneer Building/St. Paul." Yes! Yes! Yes! Now Melanie and I could allow ourselves the luxury of a walk around the observation deck of the Foshay Tower, which was surprisingly balmy considering the temperature on the street. I think I saw my house from up there.

We thanked Jennifer for her assistance and then went to Manny's Restaurant, which is located in the same building, for lunch. It was nothing short of spectacular, until we ordered dessert, which then caused us a bit of embarrassment.

They should call it the Foshay. Clearly, the staff at Manny's enjoy serving this enormous, delicious, gooey, chocolatey, caramelly dessert-for-ten—at least to unsuspecting patrons. Here I was afraid it might it not be big enough to share. And the truth is, by the time our mega brownie arrived, Melanie and I were barely hungry anymore. And the wait staff smiled at us. It's fun to surprise people. Oh yes. There we sat with this enormous dessert in front of our big, round country mouse eyes.

We overdid it. Again.

—Minnesota Country Mouse

Foshay created his company with a $6,000 unsecured loan and began purchasing telephone, gas and electric power companies, financing them by selling Foshay securities in a Tom Petters/Bernie Madoff–type Ponzi scheme. He purchased utilities in Minnesota and the surrounding states.

The final chain of utilities purchased by Foshay included utilities in Canada, Nicaragua, Honduras, Mexico and twelve states. He also owned three Twin Cities banks and subsidiary businesses in thirty states, such as wholesale and retail drugs (remember, liquor was considered a drug in the 1920s), hotel companies, food and textile factories, rubber factories, flour mills and retail furniture.

In 1926, the officers of the Foshay Company, determined to have complete control over operations, decided to offer holders of common stock (stock that gave the stockholder a vote in affairs of the company), two shares of preferred stock for every one share of common stock. This enabled the officers to retire $100,000 in voting shares and give the officers complete control. This control gave the Foshay Company the opportunity to pay its top executives huge salaries. Foshay's average salary over thirteen years was $53,000 a year. In one year, he paid himself $306,000 in salaries and bonuses. Mr. H.H. Henley averaged nearly $36,000.

Plans for the historic Foshay Tower, dedicated with a three-day celebration in 1929, just two months before Wall Street crashed. *Courtesy of the Foshay Tower Museum in Minneapolis, Minnesota.*

Foshay took to selling his securities to the public

in the East, employing an army of salesmen and amassing a $22 million fortune in just ten years. He decided to celebrate his success by commissioning the Foshay Tower, a thirty-two-story structure shaped like the Washington Monument and rising to about 447 feet above street level from a larger square base two stories in height. It was to be located at 821–37 Marquette Avenue in Minneapolis. When completed, it would be the tallest skyscraper built west of the Mississippi.

The twenty-seventh and twenty-eighth floors of the building were to be his place of business and his residence, sporting three bedrooms and baths, with a fireplace, a library, Italian

Marble walls with the Foshay coat of arms and art deco ceiling in the Foshay Tower, now serving as the lobby for the W Minneapolis Hotel, Minneapolis, Minnesota.

Sienna marble walls and glass-paneled ceilings. Alas, he and his family would never occupy the space.

An article in the *New York Times*, dated August 25, 1929, called the new Foshay Tower a dedication to Washington. The guest list to its grand opening included dignitaries from Washington D.C., several provinces in Canada, governors of all the states in the United States and the presidents of Honduras and Nicaragua. The celebration lasted for three days. Foshay commissioned renowned composer and patriot John Philip Sousa to write a rousing march, entitled the "Foshay Tower Washington Memorial March," for the price of $20,000 to be performed by Sousa's band. Foshay reportedly spent $116,000 on the event. Twenty-five thousand guests were invited to the event, where half-nude women danced as entertainment, and each guest received a gold pocket watch.

Left: Original copy of the "Foshay Tower Washington Memorial March." *Courtesy of the Foshay Museum in the W Minneapolis Hotel, Minneapolis, Minnesota.*

Below: Wilbur B. Foshay at the grand opening of the Foshay Tower in 1929, Minneapolis, Minnesota. *Courtesy of the Foshay Museum in the W Minneapolis Hotel.*

What the public celebrating the grand opening did not realize was that Foshay's fortune was the product of smoke and mirrors. Checks began to bounce, including the one for $20,000 issued to Sousa. As a result, Sousa refused to let the march be played again until the debt was paid. In 1988, a group of investors from Minnesota repaid the debt to Sousa's estate, freeing up the march to be performed. (You can listen to a rendition of it at the Foshay Museum on the thirtieth floor, which also provides access to the observation deck.)

Two months after Foshay's over-the-top celebration, the most devastating Wall Street crash in history shook the country. The timing of the crash was a thing of beauty for Foshay because the story of his financial failure could now highlight him as a victim of circumstances beyond his control. Foshay's companies had an estimated value of $20,000,000, but his liabilities were $19,000,000, not including the $29,000,000 in securities sold to the public. Foshay had flown a banner declaring, "Never has an investor of the company lost any money. All your money—All the time—On time."

The men who headed the Foshay Company were those who had previous experience working for the largest utility companies in the nation. They regularly "wrote up" or "appreciated" the company's capital account. Red flags began popping up for the Commerce Commission of the State of Minnesota, which denied the company the right to sell 1,000 additional shares of preferred stock because, the commission said, the company's holdings were too scattered to permit economical operation by the holding company and the values of the property and stock turned over to Public Utilities Consolidated Corporation were not sufficient to support the proposed capitalization. Lastly, the earnings of the respective operating companies were not such as to justify the proposed capitalization and the holding company. The Commerce Commission, in denying the application for registration, expressed the opinion that the sale of these securities would "work a fraud on the purchasers thereof."

By December 1928, the Foshay Company was employing 151 full-time and 30 part-time salesmen peddling Foshay securities. Between 1921 and 1929, they sold 63,895,521 securities. His salesmen were instructed to point out that these securities were "Foshay managed," supposedly making them safer than an alternative security. In reality, Foshay was running a pyramid scheme. For instance, in 1920, the net income earned was $2,999.07, yet the dividends paid were $5,293. The following year, the net income was $7,003.45, and dividends were paid to the amount of $11,901.13. Between 1920 and 1929, the Foshay Company paid $1,104,994.88 in dividends.

The company's accountant testified in court that dividends were paid every year out of either selling stock or borrowed money. They paid dividends even while they were losing money. In addition, Foshay exercised the unusual policy of selling securities with which to purchase property after a contract had been signed with the seller. He was "selling securities in advance of delivery." He then appreciated his purchase's value and sold it to a holding company.

In addition to salesmen spreading the word on the soundness of investing with him, Foshay came up with the idea of purchasing small-town newspapers with which to "mold" his readers' minds. Writing to Mr. Henley, he explained that if they acquired two or three hundred papers, they could control the country's policies because readers are the ones electing officials. The plans could not be carried out; they were brought up short by the company's demise.

The idea of Foshay owning Minnesota and North Dakota newspapers did not set well with Mr. R.F. Pack, vice-president and general manager of the Northern States Power Company, leading to a heated exchange of letters. Foshay loved publicity, and in 1928, one year before its great fall, the Foshay Company secured 660,000 lines of newspaper publicity, the value of which it claimed would be $2,310,000.

The reality of the failure was overexpansion, depreciation, creative bookkeeping and ego. Foshay's company went into receivership, to be managed by merchant-banker Joseph Chapman.

PAYING THE PIPER

Charges were brought against Foshay and Henley after stockholders lost millions of dollars in investments that Judge J.W. Woodrow from the federal court of appeals called "merely a dishonest scheme." According to the November 14, 1933 edition of the *New York Times*, the judge explained:

> *People buy shares in corporations to share in their earnings and these appellants always made the representation that Foshay companies had had, and would continue to have, large earnings, and would pay and continue to pay large dividends on their stock.*

In March 1934, the two men were ordered to surrender within thirty days to start serving fifteen-year sentences in Leavenworth Penitentiary.

Meanwhile, Berry Ervin, the head of a committee from Minneapolis, presented a petition to President Roosevelt seeking executive clemency. He asked that Foshay and Henley be either pardoned or placed on probation, claiming that there was no fraudulent intent at any time made by either man. Similar petitions were also being circulated in Wisconsin and Arizona.

On January 27, 1937, Attorney General Cummings announced that President Roosevelt had commuted the sentences of Wilbur Foshay and H.H. Henley, making them eligible for parole immediately. Cummings said the commutation was the result of hundreds of letters asking for a reduction in the men's sentences. Ten years later, on June 27, 1947, the Justice Department announced that President Truman had granted a pardon to Wilbur Foshay. But the story doesn't have a happy ending for everyone.

CASUALTIES OF THE CRIME

In a strange and tragic twist, a former employee and her family became casualties of Foshay and Henley's crime. Mrs. Genevieve A. Clark was found guilty of criminal contempt with attempt to obstruct justice and knowingly misleading others in her qualifications as a juror for the Foshay and Henley case. Court records show that when she was called to be a juror, she called her sister, Mrs. Brown, and told her she would prefer not to serve. Her sister checked with the clerk of court and was advised that any excuses would have to be presented to the judge.

Shortly after that, Clark was advised that she would probably not be called to serve on the Foshay and Henley case due to the fact that she had been employed by the Foshay Company. However, on the day of the trial, when she and her husband went to the courtroom for the district judge to examine her, Clark told several women there that she wished to serve on the jury. She admitted that she had worked for the Foshay Company as a stenographer for about two weeks in the summer of 1929 but said she had never met either of the defendants.

In addition, she had worked as an assistant cashier in a bank in St. Paul, where her husband was president and where Foshay banked. Mr. Clark resigned his position in 1925 but continued a business relationship with Foshay after his resignation. Letters gathered for Mrs. Clark's appeal show a warm and almost intimate relationship between the two men. When called to the jury box under questioning by the judge, she was asked if she had ever been in business of any kind. She admitted that she had been a stenographer before her marriage, going on to say that she had

also worked in a bank, in a real estate and insurance company and for an automobile concern with a Nash agency. She convinced the judge that her mind was clear of bias and that the law and evidence would govern her arrival at a verdict. She was accepted on the jury. (To see how to rig a jury, refer to the chapter on Leon Gleckman.)

During the eight-week trial, Clark mentioned to other jurors that she saw Foshay as the victim of circumstances. She told them that he had gone to New York in the fall of 1929 to borrow $18,000,000 but that because of the market crash, he came home without a penny. During deliberations by the jury once the case drew to a close, Clark announced that since the prosecutor could not convince her of wrongdoing, she couldn't see how the others could find the defendants guilty. When the jurors tried to reason with her, she put her hands over her ears and refused to reply to their comments.

She informed the other jurors that the witness for the government, Mr. C.M. Coble, an Omaha accountant, had once given perjured evidence in an attempt to convict an innocent man in a previous trial. This information had been given to her by her husband in front of the bailiff when he visited her in the hotel where the jury was staying. Due to Clark's refusal to agree with her fellow jurists, the jury was discharged with eleven of the twelve votes finding Foshay and Henley guilty.

On November 4, 1931, the government filed a case against Mrs. Clark, arguing that her answers upon the voir dire examination by the judge were

> *willfully and corruptly false, and that the effect of her misconduct had been to hinder and obstruct the trial. In response to the rule to show cause, the defendant filed an answer denying the misconduct, and alleging that her vote for acquittal had been dictated by her conscience.*

The court concluded that "the only plausible explanation is a preconceived endeavor to uphold the cause of the defendants and save them from their doom."

Mrs. Clark was sentenced to six months in prison and a $1,000 fine. Attorneys investigating precedents for sentencing could find no instance in the history of American jurisprudence of any woman who had been cited with the same crime of which Mrs. Clark had been found guilty. The severe sentence was too much for the Clarks.

Time magazine carried the following article in its May 8, 1933 "Milestone" section:

Died. Mrs. Genevieve A. Clarke, her husband Daniel, their sons Rowland, 10, and Dean, 7; by their own hands (carbon monoxide); on a country road 15 mi. south of Minneapolis. The crash of Wilbur Burton Foshay's Northwestern utilities empire in 1929 brought him & associates, two years later, Federal charges of using the mails to defraud. After an eight-week trial. Mrs. Clark, only woman member of the jury, hung the case by singly holding out for acquittal...Convicted of contempt of court for concealing the fact that she had once worked for Foshay (two weeks as a stenographer), she was sentenced to six months in jail, a $1,000 fine. (Attorneys found no U.S. precedent involving a woman juror, few sentences so severe for similarly guilty male jurors.) U.S. Circuit and Supreme Courts ruled that she must receive either jail sentence or fine, not both. Last fortnight two St. Paul judges chose jail, ordered Mrs. Clark to begin her term one day last week. She did not appear. Three days later a farmer found the Clark family's bodies huddled in their tightly-shut automobile, a hose in from the exhaust pipe.

Once released from Leavenworth, Foshay and his wife, Leota, moved to Salida, Colorado, where the community had a job waiting for him. In the early 1930s, the construction of the Denver & Rio Grande Western Railroad negatively affected the community's businesses. It lost two mines, and roughly three thousand citizens moved out of Salida. Using his God-given gift for promotion, Foshay was hired by the Salida Chamber of Commerce as its paid secretary, and he immediately erected strings of hearts along the highway advising travelers to "follow the hearts to Salida—the heart of the Rockies." His biggest promotional hit by far was a claim of fur-bearing trout, which was so outrageous that it made the newsreels. A search online today for fur-bearing fish will bring up tons of articles, many of which include the mention of Foshay. Foshay and his wife lived very happily in Salida on an income of $150 a month.

Foshay was loved by his community, going by the nickname "Cap." His efforts proved to be successful, and in 1940, after four years with the chamber of commerce, the population of Salida was back to its previous count. It was a way for Foshay to give back to a community that supported him. He was reminded of his past glory by a photograph of the Foshay Tower that hung on the wall of his office next to a plaque with the motto: "Why worry? It won't last. Nothing does."

5
CRASH

The Dust Bowl Years

My old dad, who was born in 1917, tells a story of when he was a teenager and saw his first dust storm. He used to catch a ride to school with three other kids, and after school, a couple of the boys liked to sneak into a little shed and smoke a cigarette before heading back to their farms. One afternoon, my dad and another student, waiting patiently in the car, noticed a mean-looking cloud on the horizon. It wasn't like any other cloud they had seen before. Dad said there was an ominous feeling in the air as they watched it approaching; then, suddenly, the sky turned black, and he could barely see the shed the boys were in.

Dad laughs his big laugh then, because the boys smoking in the shed had no idea anything had changed until they opened the door of the shed and faced something they had never seen before. This was, unfortunately, only the beginning of the curse of the dust bowl years.

My mom was very little at the time but remembers how hard it was for my Grandma Rose to keep the house clean. Mom remembered watching Grandma stuff rags into the cracks around the window frames and doors, trying desperately to keep the dirt from sifting in. They had months upon months of monster dust storms from drought and hot winds that baked the crops as they stood in the fields and soiled freshly laundered sheets hung out to dry. The winds wailed from 1930 to 1936.

A Minnesota farmer in his field during the drought of the 1930s. *Photo courtesy of Gary Revier, Redwood Falls, Minnesota.*

MINNESOTA ECONOMY DEEPLY AFFECTED BY PROHIBITION

Though ranked around the twentieth state in terms of population, Minnesota was the fifth-largest supplier of beer, with 112 breweries in operation, thanks to a large German population that brought with it music, philosophy, gymnastics and lager "bier." The Germans found the land and climate suitable for growing hops and barley, and as the land of ten thousand lakes, the state provided plenty of fresh water. With the onset of Prohibition, there was a decline in the demand for some crops. However, Stearns County may have been the exception, with vast amounts of corn needed to brew its illicit "Minnesota 13" liquor.

Farmers were facing financial hardship. Years of drought and poor crop rotation bared the vulnerable topsoil, which was picked up by gusting winds and rolled across the Midwest. Farmers were already battling the forces of the big banks, which were charging as much as 14 percent interest on loans,

wiping out any chance for saving the family farm. Farmers were bearing a larger tax burden than other industries in the United States. Now they had years of drought to contend with.

During World War I, agricultural products were being shipped overseas for our allies, and prices were stable. The demand for farm products and produce began tapering off in the 1920s as war-torn countries began reclaiming the land for planting their own crops. Farm exports from the United States to Europe declined, and in addition, the need for feed for horses—which provided transportation and hauled freight—also diminished as automobiles took over those tasks.

The dust bowl hit farmers especially hard. Without grass to eat, animals were starving to death. On May 17, 1934, A.T. Foresberg, Minnesota drought administrator, proposed the largest migration of animals in the history of the United States. Two million animals, owned by thirty thousand farmers, would be removed from the dust bowl states through coordination with the Farm Credit Administration, the AAA (Agriculture Adjustment Act), the Federal Surplus Relief Corporation and other related organizations. Cattle would be sold on the open market, with one cent per pound to be paid to the farmer for the care of his family and the rest used to pay off mortgages on the removed stock.

On March 10 the following year, three starved cattle were paraded on the capitol steps in St. Paul, Minnesota, by farmers pleading for assistance. The system currently in place provided twenty-five dollars in aid per month, in feed, for a subsistence herd of ten animals or less. Farmers would then repay the assistance through cash, kind or work. The program broke down when the price of feed shot through the roof. The Farm Credit Association, however, demanded repayment in cash for any advances for feed and refused to find a way to "work it out" with the farmers.

There were a number of obstacles to passing the legislation that finally provided general relief, but eventually $1,500,000 was allotted to provide farmers with the means to get their horses in shape for the upcoming spring fieldwork.

In northern Minnesota, a group of settlers who had lived through a forest fire in 1918 met and decided to offer their pastures to the prairie farmers in an act of gratitude for the aid they had received when they suffered severe losses during their own catastrophe. Northern Minnesota was spared from the drought consuming the southern half of the state in 1934.

But the weather wasn't the only problem farmers were facing. Their livelihoods were affected by our nation's foreign policy. The following article from the *Midwest American* newspaper published in the 1930s explained:

Only eight per cent of the trade of the United States is with foreign countries. And no other great power can be as self-sufficient as this country. With the exception of such items as spices, bananas and ivory the country could cut off its foreign trade completely and no private citizen would feel any deprivation whatsoever.

This foreign trade, while it may be of great profit to the firms engaged in it, has proved extremely expensive to the country as a whole. United States has again and again sent forces of marines—at the expense of all taxpayers—to collect debts for such firms as the Brown Brothers, the City National Bank and other financial houses.

At present time the State Department is engaged in "trade balance" arrangements with foreign countries. This means that if we ship out $150,000,000 worth of goods, we will allow them to send us an equal amount of their own products. On the face of it this seems a sensible arrangement.

The difficulty is that these treaties allow Denmark to send us butter in competition with Wisconsin, Minnesota and New York; that Argentine beef and lamb and mutton are taking American markets away from American stockmen; that citizens of Chicago wear Australian woolens instead of the equally fine quality produced in Montana; that American fishermen are on relief while stores throughout the country sell canned Japanese fish, that eggs from China have displaced American eggs in many markets.

By permitting foreign farm products to come into American markets, American farmers automatically are reduced to world prices for their own produce, whatever local conditions may be or however much over world price their own costs may be. Furthermore the Argentine beef and Chinese eggs come into this country to balance shipments of munitions. It is difficult to see where the disadvantage to millions of American farmers is evened by the enriching of a few armament makers.

The Smoot-Hawley Why-Didn't-We-Leave-Well-Enough-Alone Tariff

The Tariff Act of 1930 has the debatable honor of being considered one of the most significant contributions to the Great Depression. Well before the act was ramrodded into law by a Republican majority, the United States' trade partners around the world were warning of retaliation if they had to pay higher taxes importing products. Thomas Lamont, a partner at J.P. Morgan who often served as an economic adviser to the president,

begged President Herbert Hoover, a pro-regulation (when done reasonably), pro-volunteerism Republican, not to move ahead with it. Individuals and organizations from Minnesota protested the Tariff Act, which raised the cost of importing hundreds of different types of goods to record levels, by sending a telegram to President Hoover asking him to veto it.

The Tariff Act was the brainchild of state senator Reed Smoot and Republican state representative Willis C. Hawley. The act, which was signed into law on June 17, 1930, reduced American exports and imports by more than half. Although it was Hoover's intention, when elected president, to increase tariffs on agricultural goods, he also intended to *lower* tariffs on industrial goods. Through the debates, politicians jockeyed about, adding products to the tariff list based on their own states' industries and, in many cases, raising the cost of living.

Take, for example, the high tariff on imported hides and leather. Though the original idea was to help the farmer, it ended up costing him more. When a farmer sold a steer, the hide was still on the animal. Therefore, it was the butcher, the tanner and the leather products industry that benefitted, not the farmer. With fewer leather imports, the price of domestic and imported products rose, causing the farmer to end up paying more for the cost of living by forcing him to pay higher prices for his shoes and harnesses.

Approximately 1,028 economists signed a petition in May 1930, begging the president to veto the bill. Automobile executive Henry Ford, spent an evening trying to convince Hoover to veto the legislation. The League of Nations, of which the United States was not a member, warned of a negative response, and even Canada, our largest trading partner, took its business to England.

An article from the June 20, 1929 *New York Times* read:

> *Tariff-making is the most hazardous of political occupations. Minnesota, urban and rural, has served notice on the Republican grandees of the Senate. Whatever they may be able to do, or if they do nothing, this election may be the first rumble of thunder before the storm. Heaven knows the tariff of 1922 was bad enough. Why couldn't Republicans let well enough alone?*

From 1928 to 1930, farmers were making 35 percent less in income than they were paying for production. By 1932, due in a large part to tariffs that benefitted big business, farmers earned less than 60 percent of the cost of production. Prices were affected not only by tariffs but also by foreign policies formulated by the masters of the universe on Wall Street and in Washington

when they moved from dollars backed by gold to dollars backed by the open market of trading and investments.

When the Federal Reserve took over the production of United States currency, it created what is known as "asset currency." In other words, rather than each dollar bill being backed by one dollar's worth of gold, it is backed by debt, which we may or may not be able to pay through our taxes. Money is valued according to the value of the investments and bonds (the promise of a certain amount of payment to be made by a certain date) issued by our government to the Federal Reserve. Our taxes are used to pay back the bond, plus interest, to the Federal Reserve.

The Honorable Louis T. McFadden of Pennsylvania railed in Congress against the privately owned Federal Reserve's foreign policies:

Mr. Chairman, if a Scottish distiller wishes to send a cargo of Scotch whiskey to these United States, he can draw his bill against the purchasing bootlegger in dollars and after the bootlegger has accepted it by writing his name across the face of it, the Scotch distiller can send that bill to the nefarious open discount market in New York City where the Fed will buy it and use it as collateral for a new issue of Fed Notes. Thus the Government of these United States pay the Scotch distiller for the whiskey before it is shipped, and if it is lost on the way, or if the Coast Guard seizes it and destroys it, the Fed simply write off the loss and the government never recovers the money that was paid to the Scotch distiller.

While we are attempting to enforce prohibition here, the Fed are in the distillery business in Europe and paying bootlegger bills with public credit of these United States. Mr. Chairman, by the same process, they compel our Government to pay the German brewer for his beer. Why should the Fed be permitted to finance the brewing industry in Germany either in this way or as they do by compelling small and fearful United States Banks to take stock in the Isenbeck Brewery and in the German Bank for brewing industries? Mr. Chairman, if Dynamit Nobel of Germany, wishes to sell dynamite in Japan to use in Manchuria or elsewhere, it can draw its bill against the Japanese customers in dollars and send that bill to the nefarious open discount market in New York City where the Fed will buy it and use it as collateral for a new issue of Fed Notes—while at the same time the Fed will be helping Dynamit Nobel by stuffing its stock into the United States banking system.

Why should we send our representatives to the disarmament conference at Geneva—while the Fed is making our Government pay Japanese debts to German Munitions makers?

Mr. Chairman, if a German wishes to raise a crop of beans and sell them to a Japanese customer, he can draw a bill against his prospective Japanese customer in dollars and have it purchased by the Fed and get the money out of this Country at the expense of the American people before he has even planted the beans in the ground. Mr. Chairman, if a German in Germany wishes to export goods to South America, or any other Country, he can draw his bill against his customers and send it to these United States and get the money out of this Country before he ships, or even manufactures the goods.

Mr. Chairman, why should the currency of these United States be issued on the strength of German Beer? Why should it be issued on the crop of unplanted beans to be grown in Chili for Japanese consumption? Why should these United States be compelled to issue many billions of dollars every year to pay the debts of one foreigner to another foreigner? Was it for this that our National Bank depositors had their money taken out of our banks and shipped abroad? Was it for this that they had to lose it? Why should the public credit of these United States and likewise money belonging to our National Bank depositors be used to support foreign brewers, narcotic drug vendors, whiskey distillers, wig makers, human hair merchants, Chilean bean growers, to finance the munitions factories of Germany and Soviet Russia?

…Is it any wonder that there have been lately ninety cases of starvation in one of the New York hospitals? Is there any wonder that the children are being abandoned?

…The Fed lately conducted an anti-hoarding campaign here. They took that extra money which they had persuaded the American people to put into the banks—they sent it to Europe—along with the rest. In the last several months, they have sent $1,300,000,000 in gold to their foreign employers, their foreign masters, and every dollar of that gold belonged to the people of these United States and was unlawfully taken from them.

…Why should we promise to pay the debts of foreigners to foreigners? Why should the Fed be permitted to finance our competitors in all parts of the world? Do you know why the tariff was raised? It was raised to shut out the flood of Fed Goods pouring in here from every quarter of the globe—cheap goods, produced by cheaply paid foreign labor, on unlimited supplies of money and credit sent out of this Country by the dishonest and unscrupulous Fed.

An article by Walter Liggett for the *American Mercury* magazine, dated June 1932, set forth the following description of the battle between farmers and

the moneyed interests in Minneapolis. As I read the article, I could plainly see why the Nonpartisan League, founded by a North Dakota farmer named Arthur Townley, needed to bring an insurgency into Minnesota. Stick with me because this is interesting stuff. Once I did the research, the movie *Sweet Land* took on a whole new meaning:

THE FARMERS SEE RED
By Walter Liggett

Confiscation of privately owned land for public purposes is considered by the 100% American business man to be one of the cardinal sins of the Soviet government. The very word "confiscated," indeed, has a horrific sound to him, and scares him into conservatism. Comparatively few persons, especially among those living in the larger cities, have the remotest realization of how rapidly almost the same process is going on in the United States.

Here, of course, any mention of "confiscation" is sedulously avoided. We call it "foreclosure," a much more soothing word; and instead of being nationalized, the land is concentrated into the hands of a few insurance companies, mortgage companies, bankers and other absentee landlords. However, the results are much the same as in Russia, for they separate the farmer from his land with equal effect, though our method is probably the more painful, for we make no provision for the farmer after he loses his farm. Already we have gone perilously far toward transforming the United States from a nation of independent, home-owning farmers into one of hired men and renters.

Liggett then tells of farmers from the midwestern states attending a meeting on Capitol Hill in Washington, D.C., regarding Senate Bill 1197 during the Depression:

"An act to liquidate and refinance agricultural indebtedness…by establishing an efficient credit system through which the unjust and unequal burden placed upon agriculture…may be lightened by the refinancing of farm mortgages and farm indebtedness at reduced rates of interest." Having read of the $2,000,000,000 which Congress had so promptly voted to rehabilitate the bankers, the railroads and industry in general, these simple minded sons of the soil had traversed to Washington in the hope of getting some aid in the refinancing of their mortgaged farms.

So did farmers really suffer a disadvantage compared to other businesses? Liggett explained:

Despite their [farmers'] discouragements, they persevered. They did raise crops, and behind ox teams or straining horses painfully hauled them over almost impassable roads to the grain buyers at the railroad centers. There these farmers and fishermen from the Old World, all of them used to its kindlier cooperation, encountered one of the best organized and smoothest functioning systems of exploitation which modern society has produced.

The nearest primary grain market was in Minneapolis, and it was wholly controlled by a close corporation of grain speculators, chartered by the State, and known as the Chamber of Commerce. Their elevators extended throughout the northwest, and they had, to all intents and purposes, absolute control of the market. Prices changed from day to day, according to the quotations from Chicago or Liverpool, and could be manipulated by the big operators, but the hub of the racket lay in the grading.

There were some 132 grades of grain, based on slight and highly technical differences, but with sharply varying values, and the farmer was in no position to dispute the arbitrary decrees of the grain buyers, who naturally resolved every doubt in their favor. A farmer who had laboriously hauled to town a load of wheat either had to accept the price offered, or haul his grain back to the farm. Many, many million bushels of wheat, graded at from one to twenty-five cents a bushel under its honest value, were purchased from North Dakota producers every year, later to be regraded and sold by the dealers at materially increased prices. This lucrative graft ran close to $10,000,000 in a normal year on the wheat crop of North Dakota alone.

Dockage was another adroit device whereby money was diverted from the pocket of the farmer. Sometimes a load of what would contain eight or ten bushels of flaxseed. The farmer would be docked for the weight of the flaxseed, which would be separated by the elevator, though often it was worth more than the wheat from which it was taken. The farmer, however, was not paid a cent for this "wastage."

Impelled by seasonal necessity, the farmers all harvested their grain at approximately the same period; and, since no storage facilities were provided except those controlled by the Minneapolis Chamber of Commerce, they were compelled to market their crop immediately after it had been threshed. This gave the market manipulators their opportunity. Declaring that the "heavy rush of grain had unsettled the exchange," they would depress the

price until the farmers had disposed of their grain. Then the price would soar, and the speculators would profit accordingly.

If some individual farmer tried to hold his crop off the market, pressure would be brought to bear upon him by the local banker. Most such Shylocks had been set up in business by the Minneapolis gang and played its game. They charged 10%, 12% and even 14% interest during the pioneer days, and they saw to it that notes—as well as farm mortgages—became due immediately after the harvest season. This made it impossible for any considerable proportion of the farmers to hold their crops for higher prices. Moreover, as I have said, few of them had anything like adequate storage facilities on their farms.

GOVERNOR FLOYD B. OLSON HALTS FARM FORECLOSURES

Governor Floyd B. Olson assailed "economic imperialism" in a speech in 1932 over a proposal to abolish state banks and put them under national control. He argued that he believed the economic imperialism controlled by the Federal Reserve was "trembling in the balance" and was not keeping pace with the country's democratic political movement: "It is calloused and indifferent to the distress and misery of the mass of people at the base of our economic struggle."

In 1933, the Minnesota legislature, with Governor Floyd B. Olson at the helm, passed emergency legislation stopping farm foreclosures until farm prices began rising again. In addition, on May 12, 1933, Congress enacted the Agriculture Adjustment Act, in which farmers agreed to reduce the

A farm family from southwestern Minnesota. *Photo courtesy of Monica Fischer, Wabasso, Minnesota.*

number of acres they raised crops on in order to help raise crop prices. The subsidies were originally collected through taxes paid by processors of farm subsidies, but that was ruled unconstitutional. In 1936, it was ruled that farm subsidies would be paid through a general tax pool.

On November 7, Olson wrote an article for the *New York Times* regarding a hearing he attended on behalf of five midwestern agricultural states. He called the hearing unsuccessful but not fruitless. He insisted they were given a thorough and sympathetic hearing before President Franklin D. Roosevelt and the Department of Agriculture but were unable to persuade them to help provide fair prices for agricultural products. He wrote that even though federal farm credit organizations were making a credible effort to refinance farms, changing the names of the creditors was not a real solution. He feared that by the time real solutions rolled around, most farmers would have lost their farms:

No government in history has ever succeeded in solving a crisis in its affairs by depending entirely upon the voluntary action of its people. That is true in times of war. In times of war this government has never hesitated to regulate the affairs of its people by compulsory action. This war against poverty, as has often been said, is a greater war than any military conflict in which we have ever been engaged. It absolutely requires compulsory action.

Olson also championed the creation of cooperatives, asking for paternalism from the government in the same manner it showed to "individualistic enterprises." He believed it would be beneficial for farm organizations and cooperatives to own and operate their own packing plants, stockyards and other businesses in the production of bringing agricultural goods to the market. He felt that agriculture was at the mercy of big monopolies. Thanks to the Capper-Volstead Act adopted by Congress in 1922, sponsored by Senator Arthur Capper of Kansas and Representative Andrew Volstead of Minnesota, groups of producers could act together to lawfully market their products. Until then, farmers were prosecuted for working together to bring their produce to market.

Time to End Prohibition

Swedish professor Halvdon Koht of Oslo University, a guest lecturer at the University of Minnesota in 1931, observed a change in the American spirit during Prohibition and the Depression. As a man who visited the United

States on a regular basis over a twenty-year period, he was able to witness the decline of its citizens. Where once he observed great optimism, he now saw a loss of hope. A working man felt he would never rise to a higher level. He observed men and women expressing the sentiment that there was no change in sight. They were affected to their very souls by the hardships brought about by the Great Depression and Prohibition.

The 5-8 Club

5800 Cedar Avenue South in Minneapolis, Minnesota

I was talking to Sally, the assistant manager of my apartment building, telling her about my upcoming visit to the 5-8 Club. She surprised me be saying that the uncle of a friend of hers, during Prohibition, used to deliver liquor to the 5-8 Club when he was seventeen years old. You don't say.

She offered to find out if he would tell me about his experiences, and I waited in hopes of getting some great firsthand stories from the uncle. Who did he know and what did he see? But alas, it wasn't meant to be. The uncle was not a bit interested in sharing his memories. In fact, he wasn't interested in talking about it at all. Now I'm more curious than ever. After all, who doesn't like talking about themselves?

My friend Melanie and I had a date to meet a manager and be introduced to Juicy Lucy at the 5-8 Club at the intersection of Cedar and Fifty-eighth Streets in

Entrance to the 5-8 Club at Fifty-eighth and Cedar in Minneapolis, Minnesota.

Juicy Lucy, the famous burger featured on the Travel Channel's *Food Wars.*

Minneapolis. We were welcomed by a young woman named Penny, who showed us around this former speakeasy.

We followed her like a couple of ducklings, winding through the kitchen and down the stairs to the lower level, where patrons of years past enjoyed illegal liquor during the Prohibition era. Drinkers could slip into the basement of this blind pig through a back cellar door. We looked hard for evidence of the former speakeasy and spotted old nails still pounded into a timber for hanging coats on. Penny told us the building is haunted by a ghost named Mary. We guessed she was a former, um, woman of questionable morals, employed at the club in the 1920s.

We went back to the dining room and ordered our meals, looking at old photos of drinkers demanding their beer and getting hungrier by the moment. And then we met Lucy.

Talk about a bad girl (in a good kind of way). Juicy Lucy was such a great burger that I've already told Big Carl he's going to be accompanying me back to the 5-8 to see this burger for himself. He's the kind of man who can handle Lucy. When Melanie cut our burger in half to share it, we found it full of melted cheese. I suddenly wished I had ordered my own. Now I can't wait to try a bolder version of Lucy I saw listed on the menu, filled with cheese and other tasty delights.

Melanie and I ate out on the covered patio, where we could see a grove of cottonwood trees, giving us the feeling of being out in a hideaway. If you squint, and use your imagination, you might even get the sense of slipping back to the days of bootlegging and outlaws. That's what I like to do. Good times.

—*Minnesota Country Mouse*

He said he saw a more strict caste system—a greater division between rich and poor. He also said that as far as Prohibition was concerned, although he supported it, he learned from living in Sweden that it could not be enforced. He described the prohibition of alcohol as a state monopoly, enforceable only if the population supported it. Sweden, he said, after a number of years of trying to impose its own form of prohibition, accepted the fact that public opinion went against it, and without the people's support, it could never be successful. As a result, it was repealed.

In 1931, the *New York Times* reported a rumor of the White House requesting data on brewers, causing a wave of optimism to run through the country. With an upcoming presidential campaign, it was believed that current Republican president Herbert Hoover and his party had their best chance of being reelected if they stuck with their adherence to the Prohibition cause. However, the report from the U.S. Census Bureau gave figures that presented a compelling reason to rethink their position.

The report told them that in 1914, roughly seventy-five thousand people were employed in the manufacture of beer and near beer. By 1929, after almost ten years of Prohibition, only sixty-four hundred people were employed in the manufacture of near beer. Furthermore, in 1914, before Prohibition came into effect, brewers' employees were paid $80,000,000. Those wages dropped to $12,000,000 in 1929. The income earned in the sale of alcoholic beverages had not disappeared; rather, it had gone underground, where taxes failed to be paid.

KILLING PROHIBITION

In order to kill Prohibition, thirty-six states needed to ratify the Twenty-first Amendment, which Congress passed in 1932 in order to repeal the Eighteenth Amendment. Eleven years before the amendment to repeal was introduced, the *Literary Digest* took a survey showing strong anti-Prohibition sentiments among the people of the United States, who were held hostage by the radical, single-issue Anti-Saloon League, which continued to get "dry" candidates elected to Congress. The *Literary Digest* predicted that only two states, Kansas and North Carolina, would vote against the measure. Yet, in its fervor, the Anti-Saloon League continued to cry, "No surrender, no retreat, no compromise!"

Within five years of Prohibition's demise, United States tax revenues rose from $10.6 billion, to $15.5 billion, with liquor once again being taxed as a legal commodity.

6

KID CANN

Described in 1942 by the FBI as the "Overlord of the Minneapolis, Minnesota Underworld," Isadore Blumenfield was born to a Jewish family in Romania on September 8, 1900, and landed in Minnesota with his family at the age of two. His father, a furrier, settled his family in Near North, on Minneapolis's North Side, a predominantly poor Jewish neighborhood. Cann rose from his humble beginnings to become a force so powerful that, as mayor of Minneapolis in 1945, Hubert Humphrey, with promises of cleaning up the city, was advised to leave Cann's less visible operations alone.

Cann emerged from a hardscrabble childhood, surviving the gritty kinds of experiences needed to hone a keen criminal mind. He left school at an early age to sell newspapers on the streets to help support his family. He constantly competed with the other newsboys, sometimes using force, for the best street corners. He made extra money by picking up streetcar tokens and reselling them. He found, on the streets, ways to make more money to help his impoverished family. He took to running errands for the madams and pimps of the Minneapolis red-light district. By the time Prohibition rolled around, Cann and his brothers, Harry and Jacob (Yiddy Bloom), were old enough to find ways to make serious money in the bootlegging, prostitution and labor racketeering industries, employing the practice of using bribery on law enforcement and government officials.

Cann was just twenty years old when Prohibition became the law of the land, and he was wise beyond his years. He set up a number of stills in the woods near Fort Snelling and started a "perfume factory," which required

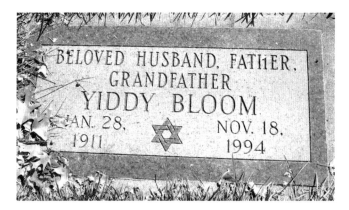

Gravestone of
Yiddy Bloom
(Blumenfield),
Edina, Minnesota.

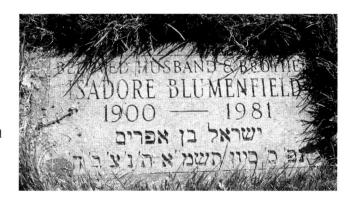

Gravestone of
Isadore Blumenfield
(aka Kid Cann),
godfather of the
Minneapolis mafia,
Edina, Minnesota.

the use of industrial-grade alcohol shipped in legally from Canada. During Prohibition, businesses could qualify for licenses giving them the right to transport and use alcohol in the manufacturing process. According to Mark Evans, grandson of slain newspaper editor Walter Liggett, the liquor syndicate of the 1930s in Minnesota was long associated with the Bronfman family (Seagram's), who ran liquor illegally across the border and into northern Minnesota from Canada. Cann had a fierce Irish opponent by the name of Tommy Banks, who led the Irish Minneapolis mob. The two avoided conflict by dividing the city into Irish and Jewish territory.

Cann became a capo (someone who has been officially inducted into the American mafia) and a lieutenant for Meyer Lansky, one of the founders of the National Crime Syndicate. Cann also ran "Minnesota 13" moonshine for Al Capone and, later, Meyer Lansky. Minnesota 13 was brewed by nearly every farmer in Stearns County. Its name was derived from a variety of seed corn developed by the University of Minnesota and favored for its heavy

Streetcar tokens from the Minneapolis/St. Paul transit system.

yielding and early ripening qualities. By 1936, Minnesota 13 seed corn was the most popular variety sold in the United States Corn Belt. To learn more about Stearns County during Prohibition, read Elaine Davis's book, *Minnesota 13*, published by Sweet Grass Publishing in St. Cloud, Minnesota.

Cann was not the only gangster in town. In 1927, after serving seven and a half years in Sing Sing Prison for a Wisconsin post office robbery, David "Davie the Jew" Berman was called to a meeting with gangsters Meyer Lansky, Moe Sedway, Lucky Luciano and Frank Costello in which he was offered $1 million in gratitude for not naming names after his arrest. Berman turned it down and asked, instead, for permission to run Minneapolis. When permission was granted, Berman moved to Minneapolis and rivaled Cann in the bootlegging and illicit gambling industries. Berman later joined Bugsy Siegel as a partner in the Flamingo Hotel in Las Vegas.

Berman's family migrated to the United States from Odessa, Russia, in 1905, to a six-hundred-acre farm in North Dakota, through the Jewish Colonization Association created in 1891 by Baron Maurice de Hirsch, a philanthropist banker associated with the Bischoffsheim & Goldschmidt banking houses of Brussels, London and Paris. The objective was to facilitate a mass emigration of Jews from oppressive regimes in Russia and Eastern European countries. He funded the purchase of land in North and South America, particularly Argentina.

Jews were not free from oppression in the United States and in Minneapolis in particular. Minneapolis was one of the few American cities that allowed the barring of Jews from service clubs, such as the Kiwanis, Rotary and Lion's Clubs, and civic welfare organizations. Jewish oppression was promoted by William Dudley Pelley, the son of a southern Baptist minister.

Pelley worked as a journalist and for most of the major Hollywood studios. He was responsible for an anti-Semitic organization called the Silver Legion of America, whose members were known as Silver Shirts. In 1936, he ran for president, representing the Christian Party. The organization's goal was to rid the United States of Jews, and he saw easy pickings in Minneapolis.

By the time Pelley came to town, Berman was a gambling czar, running his operations from the Radisson Hotel. He had been following Pelley's progress and one evening received a call advising him that a Silver Shirt meeting was being held that evening at the Elk's Lodge. Berman called all of his men and told them to be at his office at seven o'clock. Upon their arrival, he armed them with brass knuckles and clubs, and the crew drove to the Elk's Lodge, which had been decorated with posters of Hitler and Nazi flags. The leader of the Silver Shirts stepped to the microphone and began railing against the Jews, unaware of the Jewish mob just outside the front door. At a predetermined signal, the gangsters stormed the hall and began beating the Silver Shirt members.

The attack lasted roughly ten minutes, with people screaming and running for the door. When at last the scuffle ended, Berman jumped on stage, his clothes stained with blood. Calmly, using the microphone, he announced that the attack was a warning. He let the group know, in no uncertain terms, that if he ever heard of anyone badmouthing Jews again, they would have to deal with this—or worse. He put an exclamation point at the end of his statement by firing a gun into the air.

A young reporter named Eric Sevareid, who went on to launch a stellar career with CBS news, was sent by the *Minneapolis Journal* to investigate the Silver Shirts. Pelly was claiming that on September 16, 1936, based on inscriptions found on the pyramids of Giza, the Jews would rise up and conquer the world. Sevareid began printing his six-part investigation a week before the anticipated uprising—which failed to take place.

Berman went on to enlist in the Canadian army to fight in World War II, having been turned down by the U.S. Army because of his criminal past, and Pelley was eventually tried in what was to become known as the Great Sedition Trial of 1944, a show trial engineered by those who supported President Roosevelt's plan to engage the United States in World War II.

Dressed to Kill

Kid Cann was known as a snappy dresser and a man who paid meticulous attention to his appearance. He always looked good in court, where he found himself on dozens of different occasions due to a colorful criminal lifestyle.

In his forty-year career as the godfather of Minneapolis, he was arrested twenty-five times and suspected of murdering three investigative journalists: Howard Guilford of the *Twin City Reporter*; Arthur Kasherman, publisher of the *Public Press*; and Walter Liggett, editor of the *Plain Talk* magazine and *Midwest American* newspaper. All three murder cases languish in the police files, unsolved. Cann was also suspected of killing a taxi driver and two policemen—all the while enjoying close ties with government officials. Kid simply couldn't be convicted. It seems that witnesses often forgot details of incidents for which they were testifying, or they disappeared altogether.

KID CANN

My friends Melanie and Penny joined me on a Sunday morning excursion to dig up the infamous Kid Cann, buried in the Adath Yeshurun Cemetery off France Avenue in Edina, Minnesota. After that, we would be off to find a good cup of coffee. We pulled into the cemetery and looked around at the meticulously kept graveyard. How

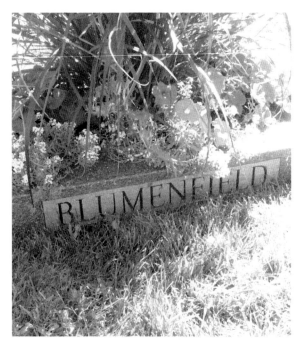

Blumenfield family cemetery marker, Edina, Minnesota.

in the world would we find him? Lucky for us, a caretaker was there doing some maintenance work, so I asked him if he knew where Isadore Blumenfield, aka Kid Cann, was buried? Well yes, of course he did.

He pointed to a section of the cemetery located down a little hill and told us his grave was in the front row. That figures. He said Kid had been getting quite a few visitors lately—which disappointed me a little bit because I wanted this to be MY big discovery. At any rate, we took a shortcut through the grass, taking care not to twist an ankle, and reached Kid's final resting place. It was odd. There they were, the Blumenfields, lying next to one another in an orderly fashion, with their headstones reminding visitors they were beloved husbands, fathers and brothers. After all of the experiences they had, the murders, the fortunes, the ties with people in high places, this is what they wanted to be remembered for—being husbands and fathers and brothers?

I hadn't expected to see everyone together, Harry, Yiddy, Isadore. I felt like I had just wandered into the Blumenfields' living room, where they stopped their intimate conversation to look at me and say, "Yes dear?" I couldn't help but wonder if what we do while we're alive even matters. In the end, in this lovely place where every grave looks exactly like the others, I wondered, "Is that how God sees us? As equals, regardless of what we've done?" I suppose, in a way, it would be for the best. Or maybe, just maybe, He loves the troublemakers just a tiny bit harder because, God knows, they need it.

—*Minnesota Country Mouse*

Cann's fellow gangsters included siblings Harry and "Yiddy" Bloom, Sam Kronick, Sam Kozberg, Edward "Bernie" Berman (a cousin of "Davie the Jew"), Sammy Stein (a close friend of "Machine Gun Kelly"), Chickie Berman (Brother of "Davie the Jew"), Israel "Ice Pick Willie" Alderman (who became a partner in the Flamingo after Bugsy Siegel was killed) and Clifford Skelly.

In 1950, the Kefauver Committee was set up to investigate organized crime in interstate commerce. During his testimony, Virgil W. Peterson, operating director of the Chicago Crime Commission, gave a summary of Cann's career:

By 1950, Cann had moved from Minneapolis to Florida where big-time racketeers had become deeply entrenched in the Miami area. He was the head of a syndicate which controlled gambling in Minneapolis and had influence in local

Isadore Blumenfield (aka Kid Cann) at center.

politics. One candidate for mayor, a few years earlier, had been approached by Cann's group, offering a large donation to the candidate's political campaign as long as the group could name who the Chief of Police would be. The candidate turned down the donation and was subsequently defeated.

He was engaged in the liquor business and owned nightclubs throughout Minneapolis. He was charged with crimes of murder, violation of the National Prohibition Act, assaults and conspiracy to kidnap Charles Urschel, a wealthy Oklahoma oil man. He allegedly ran a gambling business next door to 1538 Nicollet Avenue in Minneapolis. Family members also faced indictments, his brother Yiddy was secretly indicted by a Montana Federal Grand Jury for conspiracy in a large black-market liquor operation. Cann's sister, Mrs. Ray Schneider and his sister-in-law, Verna Bloom were indicted for illegal distribution of wine, with a tax case being settled for $73,000 in fines and criminal charges adding up to $30,000.

The only crime he was ever convicted of was the Mann Act, also known as the "White Slave Traffic Act," designed in 1910 to combat national vice rings and raise the moral tone in the United States. The act made it a felony to transport women over the state line "for the purpose of prostitution or debauchery, or for any other immoral purpose, or with the intent and purpose to induce, entice, or compel such woman or girl" to immoral acts. His conviction was overturned on appeal, but he was then convicted of offering a $25,000 bribe to a juror.

Toward the end of his life, he took on a new persona, insisting that people call him Dr. Ferguson, or "Fergie," and conveying himself as a respectable, wealthy philanthropist. And maybe in the end, he was—if you go easy on the respectable part.

7
WOMEN AND CRIME

My friend Monica dipped her toe into the life of crime when she was a teenage girl during the 1950s in Seaforth, Minnesota. Seaforth was a bucolic little village with a creek running along the edge of it. Monica's grandma, Angie, ran a pool hall and ice cream parlor there. Grandma Angie was the only woman I knew who had tattoos. I never actually saw them, but I heard about them as part of the local folklore. Monica loved living in Seaforth, and to this day she will tell you, "If you can't get to heaven, at least get to Seaforth."

I've gotten to Seaforth, and my guess is that it isn't what it used to be. Its population of horses today outweighs its population of children, but when Monica was a girl, it was a viable farming community. She had recently lost her mother and two brothers in a Memorial Day car accident, which Monica survived. After the accident, she and her father, Tony, moved from their farm to a second-story apartment above a business in town. A set of old wooden steps on the outside of the building led to their new home.

The 1950s were a simpler time, and anyone who has grown up in a small rural community can tell you there is nothing like a small-town Saturday night to feel as if anything could happen—and if it doesn't, you have a responsibility to do something about it.

On a quiet Saturday evening, Monica and her cousin Rita, along with a couple other young accomplices, committed their first crime by stealing Jimmy Katzenberger's car. His mother, Stella, owned a liquor store and went against the norms of convention, eschewing hosiery and waiting on her patrons bare legged. She smoked cigarettes and carried on brash

Seaforth Post Office, Seaforth, Minnesota.

conversations. Stella ran a successful business, using some of her profits to purchase a secondhand car for Jimmy. I think the girls liked Jimmy all right, so who knows why they decided to steal and desecrate his car, but they did.

Monica told me the following story:

> *How it started with Jimmy's car was, we were sitting on the bench in front of Angie's Pool Hall, and we knew Jimmy was out of town. So someone, I'm not sure who, got the idea to move his car and hide it from him as a joke, knowing he would have to look for it when he came home. Well, after moving it we thought, "Oh we should decorate it for him too," not really thinking of the consequences. And boy, were we not.*
>
> *We moved it into an alley. We used syrup and feathers (we opened up a feather pillow) and the car looked really pretty. I think it was a black '47 Ford or Chevy.*

Oh, they made a mess of it, all right. When the high of their antics wore off and Monica returned home to her apartment in time to beat her curfew, she began to worry. "Dad," she asked, "can syrup ruin the paint on a car?"

"No," her dad replied, being a man of few words. Monica told him what she had been up to, and feeling a sense of relief, she went to bed. Hours later, she awoke to the sound of angry heels ringing off the wooden stairway leading to their apartment, and she knew. She knew without a glance out the window that Stella Katzenberger had come to exact retribution on behalf of her son.

Phil's Tara Hideaway

15021 North Sixtieth Street in Stillwater, Minnesota

On our quest to discover former speakeasies and blind pigs the area, my friend Melanie and I came across Phil's Tara Hideaway snuggled into a grove of cottonwood trees near Stillwater in southeastern Minnesota. Originally opened as Lynch's Chicken Shack in 1929, the business burned to the ground and was rebuilt with logs in 1931. Phil's features a lovely fireplace in the dining room, and it was plain to see that an evening here could be a very romantic one.

Phil's Tara Hideaway, a former speakeasy on the outskirts of Stillwater, Minnesota.

Phil's Tara Hideaway

Restaurant and Bar

15021 60th Street North

Stillwater, Minnesota

651-439-9850

Menu cover from Phil's Tara Hideaway, Stillwater, Minnesota.

Phil's was a favorite hangout of the many gangsters looking for a little R&R from their busy lives of crime during the 1920s and '30s, when liquor was illegal.

Naturally, there were other patrons who enjoyed the secluded joint, regular folks who dined and imbibed in a little illicit liquor during the days of Prohibition. As for Melanie and me, we were blown away by the Greek menu. We shared orders of spanakopita—a sort of Greek spinach pie—and an order of Mediterranean hash, which was recommended by our waitress because it's her favorite. We dined on a feast of flavors I wasn't formerly familiar with. Looking around the cozy, tin-roofed cabin, we tried to imagine what it must have been like decades and decades ago. What would people have dressed like? What kind of music did they play?

The back dining room looks out over a grove of cottonwoods and once served as the living quarters for the proprietor and his wife. The dining staff was charming, and it was clear they enjoyed working here. Oh, if only these thick log walls could talk, the stories I bet they could tell...

—Minnesota Country Mouse

The thunder of a door being pounded with the side of a fist shook the apartment. People didn't lock their doors in Seaforth back in the 1950s, and Stella, being a keen observer of human nature, knew this. She threw open the door and stormed into the apartment with her husband, Slim, in tow.

Stella and her husband came into our kitchen, and she yelled from there that Dad should get up. She also wanted to know who the ringleader was (there wasn't any) and where we got all our supplies to do the car. Her husband, Slim, had a pencil and paper and was writing all this down! I could really see myself wearing stripes. The way they found out about us was through Slim's younger brother, Jack, who was a year younger than me. There are only one hundred people in town and about six of them are teenagers, so everyone knows everyone really well. Slim and Stella went right to his home after returning from wherever they were that night. They marched into Jack's bedroom, turned on the light and wanted to know if he knew anything about Jim's car. Well of course he knew, because we talked to him later in the evening after we did it. I think Jack was relieved that he had nothing to do with it. We didn't blame him for telling Slim and Stella, he had no other recourse. They visited all of our homes that night, starting with mine at 1:30 a.m.

"Go home, Stella," was Tony's tired reply. He didn't bother to get out of bed. Stella hurled additional threats about calling the law on Monica and then, indignantly left the apartment. Giving the door a good slam behind her, she stomped down the wooden stairs, sleeping neighbors be damned.

The car was put in a garage where everyone went to look at it. Stella called the insurance company and they sent a man out. He met the school bus one day, and we all had to wash the car in front of him while he assessed it for any damage (there was none, thank heavens). He said, "I have heard of a lot of things, but you Seaforth girls take the cake."

I will never forget when I told my Dad that I was sorry about the car, he said, "If that's the worst thing you ever do in your life, you will be lucky." After the incident was over, someone dedicated a song to the "Syrup and Feather Gang" from Seaforth on KLGR, the Redwood Falls radio station. In those days you could call in and request a song, and did not have to leave your name. I can't remember the name of the song but because I was going to a Catholic school, I was hoping the nuns didn't listen to the radio.

Monica may have considered pursuing a life of crime but was stopped short in her tracks when, at the age of eighteen, she married a handsome, straight-laced and upstanding soldier from nearby Wabasso.

I myself committed quite a serious offense once, back in my little hometown of Wabasso. I didn't know the seriousness of it at the time, but I was advised that this crime, which I didn't get caught committing, was a felony or federal offense or something like that. Thinking things through to their conclusion has never been my strong suit. Ask my family. I have, on occasion, been known to make sudden and rash decisions. It could be that I have the mind of a criminal, but my time at St. Anne's Catholic School was just enough to prevent me from making crime a profession.

It was the summer after high school graduation, and I was cruising around town, very late at night, with my high school friends Mary and Cindy. I feel bad for anyone who doesn't know what it feels like to be a teenager in a small town on a hot summer night. It was the era of halter tops and short shorts, and we were young and thin and didn't know a darned thing about life. So reaching out the open car door while we drove slowly past a freshly dug hole in the street, where maintenance crews had been working, and nabbing one of those blinking lights alerting you to the hole seemed like a fun and slightly dangerous thing to do. Unfortunately, it would have been dangerous for other drivers if there hadn't been several other flashing lights around the periphery, but as I said before, I don't always think things through. What I did think was, "Man, that light would look so cool in my new dorm room this fall!" And after all, our parents pay taxes, don't they?

Upon the advice of someone wiser than me, I returned the blinking light and went on with my haphazard life. My point is that maybe those women who got mixed up with gangsters or committed crimes of their own didn't *intend* to do it. Maybe they simply didn't think things through.

Dillinger's Girl and the Shootout in St. Paul

Researcher and writer Ellen Poulsen spent fifteen years meticulously recording the lives of the women involved with gangsters of the 1920s and '30s. In her book *Don't Call Us Molls: Women of the John Dillinger Gang*, Poulsen introduces readers to almost a dozen different women who spent the most exciting times of their lives dating the country's public enemies. The word "moll" is slang for the girlfriend of a gangster or a prostitute—though the two definitions are mutually exclusive. A gun moll holds the gun for her boyfriend's use.

The women who loved gangsters were the most loyal sort. Take, for example, John Dillinger's girlfriend, Billie (Mary Evelyn) Freschette. Freschette's father was French, and her mother was Native American. She was raised on a reservation in Wisconsin and was a member of the Menominee tribe. It could be argued that she had bad taste in men. Twenty-six-year-old Freschette met Dillinger at a dance hall in Chicago back in 1933, while her husband, Welton Sparks, was serving time in prison for mail robbery. Dillinger caught her eye from across the hall, and he didn't look away. The thirty-year-old Dillinger watched Freschette with a smile tugging at the corner of his lips. After watching for a while, Dillinger finally crossed the room. Dillinger and Freschette were introduced by their mutual friend, Larry Streng, and the two began spending time together.

Freschette was a good-looking, black-eyed, raven-haired woman and was, apparently, fearless. Dating Dillinger was no walk in the park. It was a dangerous and chaotic undertaking, rife with police chases, unfamiliar hideouts and occasional shootouts. It was a shootout in St. Paul that eventually put her behind bars.

The Lady of the St. Paul Safe House

Bessie, Mrs. Eddie (Eugene) Green, had been around the block. She was born on June 28, 1898, in North Dakota and then moved with her family to Canada, where she cared for her siblings while her parents worked at taming the land. She married a man named Nelson Skinner when she was still a teenager and moved with him to California, where she gave birth to a son she called "Skippy." The marriage didn't last, and the couple, who now resided in St. Paul, Minnesota, divorced. Bessie supported her son by working in restaurants, nightclubs and casinos during Prohibition, serving the best-known names of the underworld. In 1928, she waited tables for "Dapper Dan" Hogan, the godfather of the St. Paul Irish mob, at Hogan's Green Lantern, located at 545 Wabasha Street North.

She was promoted after Hogan was murdered by a car bomb in 1928. Hogan's successor was Harry "Dutch" Sawyer, who hired Bessie to handle the business details of the property. When the Green Lantern closed two years later, Bessie and her lover at the time, Ray Moore, purchased the Alamo Nightclub near White Bear Lake. The most well-known names in gangland during Prohibition and the Great Depression took comfort at the Alamo, drinking bootleg whiskey.

By 1934, Bessie was living with Eddie Green, and they called themselves Mr. and Mrs. Stevens. Although their source of income was bootlegging and robberies, Green left the house every morning as though joining the day-to-day workforce in the Twin Cities. Bessie shopped at the local market, taking care not to appear too ritzy, making certain she used small bills when purchasing groceries so as not to draw attention. They had made a nice home for themselves in Minneapolis when Dillinger and Freschette blew into town. Bessie disliked the couple, who brought an element of danger to the neighborhood as they settled in an apartment around the corner from the Stevenses. Dillinger and Freschette stayed briefly at apartment 106 of the Santa Monica Apartments at 3252 Girard Avenue South under the name Mr. and Mrs. Irwin Olson.

Bessie was older than most of the women who made up the Dillinger and Barker-Karpis Gangs, and her experiences had given her a level of maturity not generally achieved by the criminal element or their girls, who tended to run helter-skelter. Bessie found Freschette a poor companion, but Bessie was a good listener, gleaning nuggets of information from Freschette's over-excited ramblings. Bessie and Dillinger shared a common dislike for each other, but circumstances left Bessie an unwilling hostess.

SHOOT OUT AT THE LINCOLN COURT APARTMENTS

The historic event that eventually brought the couples down occurred at the Lincoln Court Apartments on the corner of Lexington Parkway and Lincoln Avenue, where Freschette and Dillinger were residing in apartment 303, registered as Mr. and Mrs. Carl Hellman. They lived there briefly in March 1934 while Dillinger was recovering from wounds suffered in a gunfight in Mason City, Iowa, during a bank robbery. The apartment had been secured for them by Bessie Green, who asked for a first-floor apartment but eventually agreed to one on the third floor.

If it hadn't been for Dillinger making the crucial mistake of stealing a sheriff's car and driving across the Indiana-Illinois state line after an earlier crime, he and Freschette may have enjoyed a good, long stay in the Twin Cities under the protection of crooked cops and politicians. But he had violated the National Motor Vehicle Theft Act, which was a federal offense, giving director J. Edgar Hoover and the FBI the big break they had been looking for. Dillinger was now in their territory, and unlike local law enforcement, these palms couldn't be greased. Melvin Purvis, who was put in charge of the Chicago FBI office in 1932 and who, to this date, holds the record for capturing

more public enemies than any other agent, was on Dillinger's trail with fellow FBI agent Samuel P. Cowley. Though Purvis became the media star, FBI director J. Edgar Hoover credited Crowley with Dillinger's eventual capture.

Dillinger and Freschette had guests staying with them in apartment 303. Gangster John Hamilton and his girlfriend, Pat Cherrington, were there, along with Pat's sister, Opal Long. On the evening of Friday, March 30, the group partied most of the night, and sometime near daybreak, Hamilton, Cherrington and Long left their apartment. Dillinger and Freschette, exhausted, hit the rack for some much-needed sleep.

The Lincoln Court Apartments at 93 Lexington Parkway South, St. Paul, Minnesota. John Dillinger and Billie Freschette escaped from apartment 303 while officers of the law tried to apprehend them. Dillinger was positively identified by fingerprints left on a Listerine bottle in the bathroom.

The day before, Dillinger and Freschette's landlady, Mrs. Daisy Coffey, had gone to the post office to look up the postal inspector and share her concern about the suspicious couple who wouldn't allow the maintenance man into their apartment and who had unregistered guests. By ten thirty the following morning, FBI agents Coulter and Nolls, along with Detective Cummings, began surveying the building. Venturing inside, one of the agents and a police officer knocked on the couple's door. Freschette opened the door a crack, expecting to see Hamilton. Her blood must have run cold when she realized who these strange men were and that she and Dillinger wouldn't be able to make their escape out their third-floor window.

The men asked for Mr. Hellman, and Freschette told them her husband wasn't home but agreed to answer questions for them after she had a chance to throw on some clothes. She closed the door and slid home the chain latch. The men were convinced they finally had Dillinger, public enemy number one. Reinforcements were called in, and the building was quietly surrounded.

In the meantime, an uninvited gangster, Homer Van Meter, unsuspectingly entered the apartment building. When an agent stopped him to question him, Van Meter pulled a gun and shot at Coulter. Coulter shot back, but Van Meter managed to slip out of the building. The police had flattened the tires on his car after hearing the gunshots, but his escape wasn't deterred. He stopped a passing vehicle and, at gunpoint, forced the driver of a coal truck to give him a ride to gangster Eddie Green's apartment at 3300 Fremont Avenue. Green was an expert at casing banks for robberies and had close ties with the corrupt politicians and police in St. Paul. Green couldn't have been happy with Van Meter's rash decision to get dropped off in his neighborhood, drawing attention to Green's home through his highly suspicious behavior.

After hastily packing a suitcase with their most important belongings and ammunition, Dillinger fired a machine gun round through the apartment door, mistakenly thinking that Hamilton would be covering him after hearing the gunfire exchange between Officer Coulter and Van Meter. The hail of bullets cleared the way for Freschette to make her way down the back steps, lugging the heavy suitcase with her. She dragged the suitcase to a private garage nearby, where their car, a Hudson registered to Carl Hellman, was parked. Across the street, their guests—Hamilton, Ms. Cherrington and Ms. Long—watched a crowd gather at the building they had recently left.

Freschette put the car in gear and roared to the apartment to help Dillinger escape. The volleys of machine gun fire from Dillinger's gun gave him the break he needed, and he limped to the car bleeding and shaken, having caught a bullet in his leg. The two headed to Eddie Green's safe house. At the Hellmans' apartment, the police rifled through personal effects left behind, including a row of Dillinger's childhood photographs, which had been left in the care of Freschette, and a bottle of Listerine mouthwash, on which were fingerprints that would positively identify Dillinger.

GUILTY BY ASSOCIATION

Freschette drove the car as near the Greens' apartment as possible and then got out and ran the last couple of blocks through snow to seek medical assistance for Dillinger. The frantic Freschette convinced Green to help find a doctor, and the couple was led to the home of Mrs. Augusta Salt, who resided at 1835 Park Avenue and worked as a nurse for Dr. Clayton E. May, an underworld abortionist. Dr. May and Nurse Salt treated Dillinger's leg while Freschette hid the Hudson in Nurse Salt's underground garage. Nurse Salt granted

the couple a safe haven with her, until Dillinger was able to travel again, and the couple took their leave on April 3, heading to his father's home in Mooresville, Indiana, where they were greeted warmly. Dillinger recuperated from his injuries at his father's home, and after posing for photos with his guns and with Freschette, the couple left and headed to gangland in Chicago. His father, sad to see them go, settled into worrying about his son. Dillinger's mother passed away when Dillinger was only three, and though his father raised the boy in a very strict household, Dillinger was deeply loved.

The front door of Nurse Salt's apartment building at 1835 Park Avenue in Minneapolis, Minnesota, where Dillinger was treated for a gunshot wound after his last shootout in St. Paul, Minnesota, March 31, 1934.

On April 9, 1934, unaware that their former apartment mate Opal Long had been unwittingly feeding information to the FBI through a tapped phone line while talking with their friend Larry Streng, Dillinger and Freschette arrived in Chicago. By the time they reached the city, the jig was up. When they stopped at the Tumble Inn, where Freschette was scheduled to meet Streng, who would advise her on where she and Dillinger would be staying while in Chicago, FBI agent Melvin Purvis greeted her. Streng had already been arrested. While Purvis's men were waiting outside the bar for a signal alerting them to come inside and arrest Dillinger, Dillinger himself was sitting in his car in the rain, watching them.

Dillinger allegedly broke down in tears when he saw the woman he loved being hauled away in handcuffs by Purvis's men. He didn't try to save her; he merely put his car in gear and slowly rolled away. Freschette kept her eyes

straight ahead, not drawing attention to the car in which Dillinger sat. She was arrested for harboring a criminal. The interrogation of Freschette was reportedly brutal and included withholding food and severe beatings, but she never gave up any information on Dillinger.

On April 18, Dr. May and Nurse Salt were arrested for failing to make a report of Dillinger's bullet wound. Minnesota had a law requiring that all gunshot wounds be reported. The doctor and nurse were arraigned before W.T. Goddard, United States commissioner, and both pleaded not guilty. Their bonds were both for $50,000, and a preliminary hearing was set for May 2. Also arraigned was Bessie Green.

On May 23, Freschette, Dr. May, Nurse Salt and Bessie Green were put on trial at the St. Paul Federal Building, now known as the Landmark Center, in room 317, where Freschette was sentenced to two years in prison. Although Dillinger called his attorney Louis Piquett to represent Freschette, the attorney failed to put much effort into defending her case. The *New York Times* called her "Dillinger's French-Indian sweetheart." Freschette testified in court that she knew Dillinger was an outlaw, but she loved him. Nurse Salt's thirteen-year-old son, Wallace, was summoned to testify that he saw Dillinger and Freschette in his mother's apartment and had bought newspapers and magazines for him. Mrs. Salt sobbed hysterically throughout the trial, even after she was acquitted. "I prayed for my children," she repeated over and over.

The Landmark Building in St. Paul, Minnesota, where Billie Freschette, Beth (Bessie) Green, Dr. Clayton E. May and Mrs. Augusta Salt (nurse), who tended to Dillinger's wounds, were tried for harboring a fugitive.

In contrast, Freschette received her sentence without emotion. When reporters asked for comments, she told them, "I have nothing to say." Dr. May expressed surprise at the verdict, stating he was certain he would also gain acquittal from the jury, claiming innocence.

After the shootout at the Lincoln Court Apartments, Eddie Green was in the FBI's scope. On April 12, 1934, after Dillinger and Freschette had safely left the state, Bessie asked former co-workers, two African American sisters named Leona and Lucy Goodman, with long ties working for the underworld, to pick up some items from an apartment used briefly by gangster Homer Van Meter. When the sisters arrived at Van Meter's apartment, they were greeted by two officers from the St. Paul Division of the Justice Department. After being questioned, the Goodman sisters were allowed to take the items they were sent to retrieve and return to Leona's apartment at 778 Rondo Street, where the Greens would pick them up. The men followed the women and waited for the Greens to arrive. The agents were giddy as they relished the anticipation of killing Eddie Green after the women positively identified him.

The Greens' Hudson pulled up to the sidewalk in front of 778 Rondo, and Green got out of the car while Bess waited for him. He walked to Leona's apartment, where she threw the sack of items at Green and then slammed the door. Green headed back toward the car, sack in hand. A moment later, Leona heard an agent shout, "Let him have it!" There was a sudden cadence of machine gun fire, and then silence. Bessie jumped from the car and ran toward Green, who lay on the ground in a pool of blood, having been hit in the head and shoulder. The agents rushed to the dying man, preserving the items collected from the sisters and quickly covering the Greens' car, its back tires shot to bits by the agents, with a tarp as evidence. Green was taken to Ancker Hospital (a precursor to Regions Hospital), where he lingered in a delirious state for eight days, with agents recording every word he uttered, gathering information about Dillinger, Van Meter, Hamilton and the Barker-Karpis Gang.

Immediately after the shooting, Bess was apprehended with over $1,000 on her person. She was taken into custody in an undisclosed location and questioned. Grief-stricken, she shouted at the agents, chastising them for killing an unarmed man. The G-men were ready with an excuse to counter the accusation. They defended their actions by saying that Green had used an intimidating gesture when he lifted the sack of Van Meter's belongings outside the apartment, and they were convinced he was trying to signal to other gangsters for backup on the busy street. Though J. Edgar Hoover appreciated the defense the agents employed, it seems an unlikely one considering that Green was unaware he was in danger.

In the meantime, Lucy and Leona, half crazed by what they had just witnessed, tracked down their brother, Mose, and instructed him to send a telegram to Cherrington and Long, the two women who had stayed in the apartment on Lexington with Dillinger, to let them know they were in trouble.

While Green lay dying in the hospital, the agents continued for days interrogating Bessie, who gave them information about their bank accounts opened under false names. The money included currency from the bank robbery in Sioux Falls, and another stash of money came from the sale of bootleg liquor. After a week of deprivation and questioning, Bessie agreed to share information as long as her true identity was not used in the newspaper, in an effort to spare her son from humiliation. She was now referred to as Beth Green. As Beth Green, she was eventually allowed to see her common-law husband, who now lay in a coma. Grief-stricken and exhausted, Beth Green was a broken woman.

Still trying to grasp the fact that the federal agents were not part of the graft system used so long in the Twin Cities when dealing with the law, Bessie was arraigned on charges of conspiracy to harbor and conceal a fugitive from justice, and her bail was set at $25,000. Her long association with the police, politicians and criminals in Minneapolis and St. Paul astounded the feds. She ended up serving a jail sentence from May 1934 to August 1935 at Alderson Federal Correction Facility in West Virginia—the same federal prison where Martha Stewart served her time.

Three months later, while walking out of the Biograph Theatre in Chicago with his new girlfriend, Polly Hamilton, Dillinger was gunned down by the FBI, who received a tip he would be there. Dillinger was declared dead at 10:50 p.m. on July 22, 1934. His body was taken to the Cook County morgue, where it was put on display for the public to view. A week later, Dillinger's body rode home to Mooresville, Indiana, in a wicker basket aboard a hearse and was delivered to a local morgue. He was dressed in a light-colored suit and laid in a $165 casket, which was then delivered to his sister's bungalow outside Indianapolis. Twenty-five hundred mourners paid their respects—or satisfied their curiosity—filing past the casket, which was laid to rest beside his mother's grave in Crown Hill Cemetery as rain broke the heat wave that had been oppressing the Indiana countryside.

After paying her debt to society, Billie Freschette went on the road with Dillinger's family for five years, participating in a production called the *Crime Did Not Pay Show* before seeking a quieter and more private life. She returned to her home and family in Wisconsin, passing away in Shawano in 1969.

"Talk to Their Mother, She Handles the Boys."

Ma Barker's given name was Arizona Donnie Clark, and she was born to conservative Christians in the Ozarks about 1872. She married a man named George Elias Barker, thirteen years her senior, at Aurora, Missouri, on September 14, 1892. Though her marriage license is signed Arrie Clark, she chose to go by the name of Kate. The couple had four sons—Herman, Lloyd, Arthur (Doc) and Fred—all of whom tended to have criminal tendencies. When neighbors complained to their father about the boys' petty crimes, he advised them to "talk to their mother. She handles the boys." The result was Kate railing against the accusers, insulting them and calling them liars. When her son Herman was arrested for highway robbery in Joplin, the story goes that Ma declared it time to move away from such a narrow-minded community. The family settled in a two-room shack in Tulsa, Oklahoma. George Baker left the family sometime after 1920.

The boys had a gift for finding friends of the same ilk and ended up creating a gang of delinquents in Tulsa called the Central Park Gang, which at one time included twenty-two members, many going on to commit devastating crimes. While serving time in the Kansas State Penitentiary, Fred met Alvin (Old Creepy) Karpis. Karpis was welcomed into the Barker family. Ma loved the boys and accepted their wayward leanings. On August 29, 1927, Ma lost her son Herman in a suicide when he chose to kill himself rather than be apprehended after killing a lawman in Wichita, Kansas. Another son, Lloyd, ended up serving a twenty-five-year sentence in Leavenworth for mail robbery, only to be murdered with a shotgun blast by his wife on March 18, 1949, after returning from an opening of the Denargo Grill in Denver, Colorado, where he was working as an assistant manager.

The boys got into a lot of trouble. On December 19, 1931, Fred Barker and Karpis drove their DeSoto to the Davidson Motor Company in West Plains, Missouri. They were wearing brand-new, expensive clothing, similar to merchandise recently stolen from the C.C. McMallon Store in town. The owner of the garage, Caroc Davidson, discreetly called the owner of the store to stop by and see if the items belonged to him. About the same time McCallon arrived, the sheriff, C. Roy Kelly, was walking out of the post office, and Davidson walked over to tell him that things were looking suspicious. The sheriff stopped at his car, grabbing his gun, which he held under his coat, and then crossed Main Street to question the men. The moment he entered through the door, he was hit with four bullets before he

could even pull his gun out from under his coat, and the car screamed out of the garage, bouncing off the curb on the opposite side of the street. It tore out of town.

Barker and Karpis abandoned the DeSoto near Thayer, Missouri, and it was later found by hunters, who were immediately suspicious when they saw bullet holes in the back of the car. The hunters reported the car to the authorities, and it was confirmed that the car was registered to Alvin Karpis. The police immediately identified it as the DeSoto used as an escape car at the murder of Sheriff C. Roy Kelly.

For a while after the murder in West Plains, Barker and Karpis lived with Ma and her companion, Arthur Dunlop, a drinker with a reputation for treating Ma badly. They also spent a good deal of time at the home of Fred "Deafy" Farmer, whose place in Missouri operated as a safe house for many of the day's criminals. Farmer helped purchase protection for Karpis from Harry Sawyer, a top go-between man for the cops and gangsters in St. Paul. Barker and Karpis escaped being apprehended at their Missouri hideout

when a landlady disclosed their location to a policeman on Farmer's payroll. It took the police hours to arrive on the scene, and by then, Barker and Karpis were headed to St. Paul to make their connections.

Barker and Karpis initially stayed at the Commodore Hotel in St. Paul. On December 31, 1931, they went to a gala hosted at Sawyer's Green Lantern Saloon at 545 Wabasha, where they were introduced to the elite criminals of Minnesota, including Kid Cann, godfather of Minneapolis's Jewish mob. Ma Barker kept house for Dunlop and the boys on Robert Street in St. Paul, and though J. Edgar Hoover and the FBI propagated stories

The Commodore Hotel, 79 Western Avenue, St. Paul, Minnesota, where F. Scott Fitzgerald and gangsters like Ma Barker and her boys stayed during the 1920s and '30s.

about Ma's brilliant mind for crime, all evidence points to Ma being far less savvy than local folklore allows. The boys sent her to the movies while they committed their crimes, which included the kidnappings of businessman Edward G. Bremer and William A. Hamm of the Theodore Hamm Brewing Company in St. Paul.

The boys didn't appreciate "Old Man" Dunlop, who also moved to St. Paul with the group, but it was easy to take care of that. On April 26, 1932, the body of A.W. Dunlop was found at a rented lake cabin, allegedly killed by Fred Barker and Alvin Karpis, whom the Barkers accused of leaking their whereabouts to the law.

My late uncle Gerald, a marvelous storyteller with a laugh the size of a small town, was in South St. Paul on Wednesday, August 30, 1933, the day the Barker-Karpis Gang robbed the payroll at the post office and Officer Leo Pavlak was killed. Uncle Gerald hauled livestock from southwestern Minnesota to South St. Paul for slaughter. The Stockyard National Bank payroll was arriving by train from the Federal Reserve Bank of Minneapolis that day, and the Barker-Karpis Gang was ready to claim it.

Uncle Gerald didn't see the shooting, but he said when he returned to his truck after taking care of some business, he saw a friend of his crawling out from under his vehicle, where he had dived for safety. His friend was panicked and pointed to the Stockyards Exchange Building, which was pocked with dents from flying bullets. "Didn't you hear the gunfire?"

The crooks got away with $30,000. The gang was wearing out its welcome, and Ma and Fred packed their things and headed south.

The house where Ma Barker lived with her boys at 1031 Robert Street S, West St. Paul, Minnesota.

On January 8, 1935, Doc Barker was arrested in Chicago, and a map in his possession led the FBI to Oklawaha, Florida, to a cabin on the shores of Lake Weir, where Fred and Ma Barker were hiding out under the name of Blackburn. According to an article published in the *New York Times* on January 16, 1935, at daybreak, Department of Justice agent E.J. Connelly of Cincinnati and his agents surrounded the house and called for Fred, age thirty-two, and Ma, age fifty-five, to surrender. The response was machine gun fire, which was answered with machine gun fire and tear gas. About 11:00 a.m., the article says, a "Negro" cook, who had been working there, was sent into the house to check things out. He returned to the agents, announcing, "They are all dead."

It was reported that Ma's body was found with a machine gun in her hands, a portion of the bullets in the ammunition drum exhausted. The veracity of this statement is questionable, but it is the image J. Edgar Hoover wanted portrayed to the public after killing a woman in a shootout. She died from one gunshot wound to the head. Her son's body was riddled with eleven machine gun bullets in his shoulder and three in his head.

After the shootout, the agents ransacked the summer house, hoping to locate some of the $200,000 Bremer ransom, but they found only four $1,000 bills on Fred. Neighbors said they knew little about the Blackburns, other than that they had a great deal of company very late at night.

Mrs. Westbury, who lived across the street, likened the siege by government agents to being in a war. She awoke to the sound of gunfire, and while leaving her bedroom, bullets ripped through the bedroom door and hit the head of her bed. She opened the bedroom door a crack, and several more bullets hit the door above her head.

She quickly got her small daughter out of bed, and they crawled out through a window on the backside of the house, intending to run to a neighbor's home for safety. She and her daughter lay on the ground for a little while between the houses and then, as the shooting got louder, jumped up to run to safety. They heard a man yell at them to stop, but they were too frightened. They kept going and suddenly found themselves being shot at by the very men who were supposed to be protecting them. "We kept on running, and they kept on yelling and shooting."

The Barkers' bodies were kept in a morgue for eight months before they were brought to Welch, Oklahoma, and buried in the Williams Timberhill Cemetery, where the oldest Barker son, Herman, had already been laid to rest.

Women and crime. They just don't seem like they should go together.

8

THE MURDER OF INVESTIGATIVE JOURNALIST WALTER LIGGETT

Who Killed Minnesota's Journalists?

Minnesota was a perilous place for investigative journalists during the 1920s, '30s and '40s. Often referred to as muckrakers, their goal was to expose unscrupulous relationships between the mob and the law. Danger lurked in the dark underworld of gangsters and bootleggers and, much to my surprise, in the halls of our state capitol. Among those murdered was editor of the *Midwest American* Walter Liggett.

Walter Liggett

Walter Liggett was born on February 14, 1886, on his parents' stock farm near Benson at the far western edge of Minnesota. Liggett's relentless drive for justice and his support of farmers was the result of his parents' worldviews.

Liggett's father, William Madison Liggett, specialized in breeding livestock suited to Minnesota's harsh climate. His innovative work was highly regarded, and he was appointed as a regent on the University of Minnesota's board, headed up the School of Agriculture and was elected by local farmers to supervise the Minnesota State Fair. In addition, he was appointed director of the agriculture experiment stations around the state and became the first dean of agriculture at the university. In 1897, he helped make it possible for women to attend agricultural college.

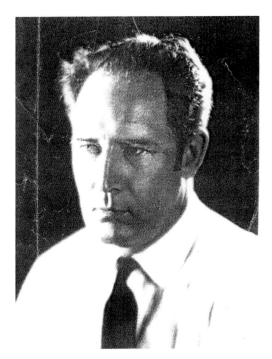

Walter Liggett, editor of the *Midwest American Newspaper*, was gunned down by Kid Cann in an alley in Minneapolis. *Image courtesy of Mark Evans.*

The alley in Minneapolis where newspaperman Walter Liggett was gunned down.

Liggett's mother, Mathilda Root Brown Liggett, did not take her good fortune for granted, dedicating her life's work to serving those in need, looking out for their welfare and battling the "deadly limitations of an artificial social standard." Out in the rural areas of Minnesota, farmers were at odds with banks, needing access to credit with which to purchase seed and equipment. In addition, they were at the mercy of the railroads, millers and grain cartels, which controlled the price of wheat.

Liggett was raised in St. Paul, spending his summers in the country. He inherited his parents' passion for equality and empathy for those struggling to succeed in a society unfairly rigged in favor of, and by, the powers of the time. As a teenager, he discovered *McClure's* magazine, published by Samuel McClure. In 1903, McClure published an article called "The Shame of Minneapolis," an exposé by writer Lincoln Steffens. The article exposed the Alberto Alonzo "Doc Ames" administration's corruption. The urge to join the league of investigative journalists caught hold of Liggett and refused to let go—eventually costing him his life.

He attended his father's agricultural school for a short time but left when he was nineteen to begin working as a reporter for the *St. Paul Pioneer Press*, *Minneapolis Daily News* and the *Minneapolis Journal*. From there, he moved on, working as a journalist in Duluth and later for the *Fargo Forum* in North Dakota. He held newspaper positions in Seattle and Alaska, giving him a well-rounded understanding of politics and economy throughout the United

My friend Melanie and I have recently become sleuths, visiting crime scenes from the gangster-dominated Twin Cities of the 1930s. We're Sherlock Holmes and Watson. I recently read the book Stopping the Presses, *written by Marda Liggett Woodbury, daughter of murdered newspaperman Walter Liggett and witness to the crime at the tender age of ten. I was excited.*

This trip had a completely different feeling than, say, visiting the University of Minnesota Arboretum. We had our map and our book ready to make sure we were in the proper alley. The first alley we looked at wasn't quite right. All of the buildings had arched windows, and those pictured in the book were plain old rectangles. For those of you under the impression that you can walk down an alley without being observed, you would be wrong.

While Melanie was showing the photos in the book to a group gathered in an alley parking lot, the owner of one of the buildings approached me asking why I was

taking pictures of his property. I began explaining, when Melanie scooted over to us to let me know that the alley we wanted was actually two blocks over. Oh. Never mind.

We hopped back in Melanie's hybrid and then turned into the exact alley we saw pictured in Woodbury's book. Oh my. I could practically see Kid Cann's leering face speeding past the Liggett family with his Tommy gun blasting, leaving five bullet holes around Walter Liggett's heart.

Liggett had been busy exposing the ties between Governor Floyd B. Olson's office and the gangsters who had taken it over. This is not to say that Olson lost touch with the suffering of the poor during the Depression. Many considered him a hero during his tenure, instituting programs to help keep the poor from starving altogether. Still, he probably shouldn't have been doing some of the things he did.

In spite of Mrs. Liggett's positive identification of the murderer, Kid Cann was acquitted. What in the world?

So, I snapped my photos and drifted back into 2010 from a cold December evening in 1935. Then, Holmes and I left the crime scene, ready for our next big adventure. Stay tuned.

—Minnesota Country Mouse

States. While in Alaska, Liggett met and married a young woman named Norma Ask.

The Liggetts moved to Tacoma, where Walter worked for the *Tacoma Ledger*. Liggett, along with another reporter, purchased a weekly newspaper, the *Pasco Progress*. Among other progressive causes, Walter Liggett called for the creation of a mighty power project a little farther up the Columbia River. As Edith Liggett wrote, "He was called a wild visionary; his plan was ridiculed. Today the plan is a fact. It is called the Grand Coulee Dam." In 1915, upon the death of his younger sister, Gladys, Liggett returned to his roots in Minnesota.

THE NONPARTISAN LEAGUE

The Nonpartisan League was the brainchild of Arthur Townley, a failed flax farmer who, along with two other farmers, traipsed from homestead to homestead in the frigid winter of 1915 in North Dakota, asking for the residents' cooperation in joining the Nonpartisan League, which was to be a consortium of farmers with a five-point plan: state-owned grain elevators and

mills, state inspections of grain and grading, state hail insurance, rural credit banks and tax exemptions for farm improvements.

The league grew very quickly and quietly, eventually publishing its own newspaper, the *Nonpartisan Leader*. Its membership grew to twenty-two thousand farmers. Though not a political party, it was successful in electing mostly Republican candidates into office and capturing the governorship, three Supreme Court judgeships and all state offices, with the exception of the office of the treasurer. It was one of the most successful examples of democracy in our country's history.

The preserved Gimmestad Land Office in Belview, Minnesota.

The league helped women gain the right to vote, tripled aid to rural schools, established adult evening school classes and created a public welfare commission with a female commissioner. The Nonpartisan League migrated to Minnesota, an important step for the state's farmers, since the individuals who controlled the price of grain resided in the Twin Cities. The group also held an antiwar stance.

MINNESOTA COMMISSION OF PUBLIC SAFETY CREATED TO TERRORIZE PRO-PEACE CITIZENS

In 1917, Republican governor Alfred Burnquist established the Minnesota Commission of Public Safety (Chap. 261, Laws 1917) giving the legislature broad authority with which to terrorize those citizens opposed to joining World War I and radical citizens seeking legislative change, focusing heavily on immigrants who spoke foreign languages, particularly German. The commission's activities were dominated by an aggressive, if not somewhat paranoid, judge—John. F. McGee. McGee used informants to monitor public sentiment of the world war, keeping a file of index cards dividing Minnesotans into patriots and traitors. He also set his sights on unions and organizations

like the farmers' Nonpartisan League and the laborers' Industrial Workers of the World (IWW). The commission was given free rein to defend the state and nation from "subversive" activity and to prosecute the war:

> *To do acts and things non-inconsistent with the constitution or laws of Minnesota, or of the United States which, in the event of war existing between the United States and any foreign nation, are necessary or proper for the public safety and for the protection of life and public property requiring protection: and all acts and things necessary or proper so that the military, civil and industrial resources of the state may be most efficiently applied toward maintenance of the defense of the state and nation, and toward the successful prosecution of such war.*

The commission considered Minnesota and Pennsylvania the two most important states in the Union based on the fact that our iron mines provided 84 percent of iron mined in the United States, and Pennsylvania had extensive anthracite coal mines. Minnesota's farmers produced one-tenth of the grain and dairy products in the country. Its 1918 report laid out the commission's thinking:

THEORY OF THE LAW

> *As one of the country's largest granaries and dairies and the main source of indispensable iron ore, Minnesota held a paramount position among states when war came. If we were to win, the maximum production of her staples must be in every way stimulated. Government plays only a minor role in production in times of peace. Stated broadly it preserves order and leaves the rest to the individual or to voluntary concerted enterprise. The hope of profit is then the chief incentive to effort. If the best results are not realized because workers are idle, dissolute or inefficient, or because the wheels of industry are clogged by class quarrels or the application of false social doctrines, those who cause the troubles are usually those who suffer from them; time can be counted on to bring the cure, and the state as a whole is only indirectly affected. But when the country's life is at stake, the situation is different. The operation of the industrial machine ceases then to be private and becomes a public matter. If our soldiers need food and munitions, the man who will not help to their supplying according to his ability, or who, by his conduct, interferes with others producing, is as much an enemy of the country as those in arms against it. As a war power and for purposes of self-preservation, the government can stimulate general production by suppressing the things which are calculated to retard it, and in so doing, it is exercising as legitimate*

and constitutional a function of the same sort as that which it exercises in maintaining and operating armies. It goes without saying that a state which has the right to use its strength to crush its foreign enemies can also protect itself against those at home whose behavior tends to weaken its war capacity.

But while all this might be admitted, the creation of a body like the Commission to do this sort of work, seemed to many people extremely novel and unusual, and the hostility which some of its activities excited is a matter of common knowledge. It is true that there was no similar legislation in Civil War times. The method of handing seditious talk and action of furthering war activities then adopted was not the employment of civil agencies, but was recourse to the strong arm of the military commander. But in revolutionary times, there was a council of safety appointed July 2, 1777, in Vermont, and in public interest it effectively discharged functions very similar to those exercised by the Minnesota Commission. The idea is, therefore, not without American precedent, and the law itself, and what has been done under it, as a proper exercise of legislative power, have been sustained by every court before which any of its phases, or any of the Commission's procedure, have been put in issue.

The commission used patriotism as a weapon to destroy the Nonpartisan League in 1918, attacking its members as disloyal pacifists for taking exception to war profiteers not being taxed, as mentioned in the commission's report:

The public danger came when the anti-war feeling assumed the shape of concerted and public propaganda, and it assumed this shape here in the spring and summer of 1917. The Minnesota men who were disloyal in the sense above defined then formed a constituency of considerable size and there appeared leaders and spokesmen to organize them and give expression to their opinions. Misinterpreting the constitutional guaranty of freedom of speech and of the press, these leaders thought or pretended to think that even in war times, they could properly oppose the government's policies in speech and writings. These leaders were of three classes:

(1) Professional and theoretical pacifists who organized for a nation-wide anti-war campaign, the so-called People's Peace Council and similar bodies.

(2) Men of pro-German traditions and Sympathies, who were opposed to the war because Germany was one of the combatants. The troubles from this type of leaders showed themselves first most conspicuously in the Minnesota Valley culminating in the New Ulm episode in July, 1917.

(3) Professional politicians of the socialist or Non-partisan league stamp, who sought to win votes at their country's cost by pandering to a treasonable

sentiment. The Commission undertook to kindle the back fires of patriotism among the rank and file of this ilk by the devices already referred to. With the leaders it used the mailed fist.

The commission defended itself in its reports as it treaded on civil rights with intimidation and arrest in an effort to prevent socioeconomic change.

The Commission collated the evidence against socialist agitators by having its agents attend meetings addressed by them, and where there appeared a violation of the Espionage or other federal acts, laid the evidence before the United States Attorney and secured their indictment. The Commission does not care to include their names in this report, but it was at its initiative that many of those subsequently convicted, were brought to justice.

There was a public outcry, and at the conclusion of the war, the U.S. Supreme Court ruled that the Bill of Rights must be protected from state interference, thereby preventing further abuse by state governments.

To his credit, Governor Burnquist initiated legislation, including disaster assistance programs, improvement of state highways and, most importantly, programs looking after the welfare of the state's children.

Wife, Edith Liggett: "Walter was writing for a St. Paul newspaper… when his editor sent him to cover a speech by the elder Bob LaFollette. [Who had come up to the twin cities to stump for the cause of the Non-Partisan League.] *The paper opposed* [both the League and] *LaFollette, and Walter's orders were to prove by the old liberal's own words that he was a menace to the nation. But Walter, swept away by LaFollette's oratory, stood up in the meeting and applauded, and when he got back to the office the story of his applause was there ahead of him. So he was out of a job again, and on LaFollette's bandwagon.*

Another account, unearthed by the research of Marda Liggett Woodbury in the course of writing her book, states that Liggett (who already supported the Nonpartisan League's views) talked a janitor into bringing him the managing editor's wastepaper basket. Rifling through discarded articles, he came to the realization that his employer was less interested in reporting the news with journalistic detachment than in supporting the current administration.

So, whether he was fired or left voluntarily, Liggett left the *St. Paul Dispatch* and accepted a position as head of publicity for the Nonpartisan League, where he

wrote dispatches for thirteen midwestern states, and macro managed a total of fifty-six Nonpartisan League local newspapers, as well as a weekly Washington newsletter supporting the league's goals. He was the force behind the creation of farmer-owned newspapers, providing a balance with those owned by the elite.

CHARLES LINDBERGH SR. RUNS FOR GOVERNOR

In 1918, Charles Lindbergh Sr., former congressman from Little Falls, was chosen by the Nonpartisan League to run for governor of Minnesota as a write-in candidate in the Republican primary. Lindbergh, who had just been bell, booked and candled out of the Republican Party—and Congress—was known for his articulate and long-winded, opposition on the floor of Congress to the development of the Federal Reserve in 1913 and the takeover of the U.S. economy by a few privately owned commercial banks, which continue to own the Federal Reserve Bank. He was also known for his principled opposition to America's entry into the Great War.

In the introduction of his book *Why Is Your Country at War*, he clearly stated a need for the people to support Congress and the president of the United States, yet reminded them that it was their right as sovereign citizens of the United States to direct Congress to put their demands into action. Nevertheless, he suggested that powerful individuals and corporations stood to profit from the United States' participation in the war and were—quite obviously—*forcing the issue*, making it impossible for us not to go to war.

If Lindbergh's run had been successful and he had been elected governor, Walter Liggett would have become his private secretary. In the meantime, Liggett wrote some of Lindbergh's speeches and attended public campaign events, carrying a gun to protect him from the violence directed at the Nonpartisan League from the "powers that be," though the league was not known to return violence with violence.

POOL HALL PATRIOTS THREATEN LINDBERGH WITH LYNCHING

A meeting had been planned in Cloquet, Minnesota, but never took place because the Minnesota Commission of Public Safety arrived ahead of time and bought drinks for the locals in surrounding communities, inciting anger and turning them into "pool hall patriots." Large numbers of such patriots

drove in from surrounding communities, out-numbering the farmers. Lindbergh, Liggett and the farmers were turned away by the proprietor of the theater where their meeting was to have taken place. Patriots flooded into the hall, screaming accusations that the meeting was pro-German and anti-patriotic and carrying ropes for lynching. Lindbergh, a tall man, stared down the crowd for several very tense minutes outside the theater and then commanded the crowd to "step aside." Amazingly, it did. The elder Lindbergh walked through the angry, seething crowd to the car. Once Lindbergh was safely inside, the car was pelted with rocks, which glanced off the outside of the vehicle as his party drove away.

Members of the Nonpartisan League suffered indignities at the hands of their neighbors, who slashed tires and loaded their crankcases with shot and gravel. In the meantime, Governor Burnquist, head of the Minnesota Commission on Public Safety, held "loyalty" meetings, campaigning against Lindbergh. Burnquist narrowly won the election, under a cloud of suspicion of vote tampering.

In an environment where the wealthy believed in the right to earn reasonable profits without the need to pay reasonable compensation, laborers and farmers united, creating the Farmer-Labor Party as a political third party to fight for fairness in wages, safe working conditions and government oversight.

Among the founding members of the Farmer-Labor Party, established in Minnesota during the period between 1918 and 1920, were: Charlie Johnson, Borghild Melbye, Ernst Lundeen, Charles A. Lindbergh Sr., Walter Liggett, Richard Orth, Julius Reiter, William Friedell, Otto Scherf, A.C. Townley, Henry Biesiot, Dave Paquin, Julius Emme, William Anderson, Magnus Johnson, William Mahoney, Harry H. Peterson, Henrik Shipstead, Dave Evans, John Frei, John Baer, Oscar Kleller and Susie Stageborg. As the chief head in charge of journalism and the news service for the Nonpartisan League, Walter Liggett played a significant role.

THE 1920s ROARED IN

Peacetime reigned in the 1920s. The prohibition of alcohol was brand new in the United States, and the black market became fertile ground for unscrupulous individuals to begin the movement and trade of illegal liquor. In 1922, Liggett moved to Washington, D.C., as the speechwriter and secretary for Senator Ladd of North Dakota, the man who is generally considered to be the model for Frank Capra's 1930s film *Mr. Smith Goes to Washington*. The

Liggetts shared a large, sunny apartment with two other couples. During this time, Liggett was working part time as North Dakota's deputy commissioner of immigration. He was in charge of bringing immigrants to North Dakota to settle the land but found, in his visits to Washington, D.C., that the head of immigration was more interested in the deportation of immigrants pegged as subversive than in bringing new settlers into the country.

Norma Liggett enjoyed Washington's social life, working as bookkeeper and manager of the Penguin Club. As Liggett became more committed to fighting injustice, the couple found they had less and less in common, and though they held one another in high regard, they divorced.

While working as a journalist in New York at the *New York Call*, the organ of the Socialist Party, Liggett met Edith Fleischer, a charming, vivacious and brilliant young reporter for the *Call*. Edith's mother, née Ida Rosenblatz, had been raised in Minnesota (her father owned a very successful trading post in Albert Lea) but settled in Brooklyn with her husband, Charles Fleischer, after they were married. Edith was raised in Brooklyn and joined the Flatbush chapter of the YPSL (Young People's Socialist League) in 1914, at the age of thirteen. Walter and Edith, although fifteen years apart in age and fourteen inches apart in height, found that they shared a similar ideology and commitment to justice. They eventually married.

A word is in order, supplying the reader with a simple time line concerning the history of Prohibition in America and Canada. Most people today have never heard that Prohibition was attempted in Canada between 1915 and 1919. During this period, the illegal booze flowed from America *into* Canada, and the future rumrunning networks were developed. In 1919, two things happened: 1) Canada repealed its failed experiment and 2) America began its doomed experiment. From that time, the rum flowed in the opposite direction, and powerful families who controlled the trade became vastly wealthier than they had ever been before, utilizing the same gangsters and personnel who had been working the illicit trade during the Great War.

In the late 1920s, Liggett, as an investigative reporter, wrote a series of eighteen articles in *Plain Talk*, a monthly magazine, about the effects of Prohibition, recording the collusion of law enforcement and politicians with bootleggers. They illustrated the irony of how Prohibition agents who "accidently" killed innocent people during raids went free, yet newspaper reporters unwilling to disclose their sources spent time in jail.

In his article about his home state of Minnesota entitled "Minneapolis and Vice in Volsteadland," Liggett reported that many of the farmers who voted "dry" were brewing liquor from corn developed at the state's agricultural

college. Meanwhile, from a "farm" on the Canadian side of the border, facing an adjacent "farm" on the Minnesota side, an eighteen-inch-diameter pipeline was pumping a better grade of liquor into Minnesota, while law enforcement, paid off on both sides of the border, turned a blind eye.

During this time, under the watch of Hennepin County district attorney Floyd B. Olson, who held tenure from 1920 to 1929, the Twin Cities of Minnesota became the central point of distribution for illegal liquor in the northwestern region of the United States, run by gangs from the North Side of Minneapolis—many of whose members were childhood friends of Floyd B. Olson.

As a result of this series of eighteen articles in *Plain Talk* magazine, Walter Liggett was the first witness called to testify before the Senate Subcommittee on Prohibition in 1929, when the Senate called its first sessions to look at Prohibition was not working. And in 1931, Liggett was nominated as a runner up for the Pulitzer Prize in Journalism. As Edith Liggett wrote, "That series of articles, quoted and reprinted from coast to coast, was…the beginning of the end for prohibition."

HEADING FOR HOME

Walter and Edith started a family. A son named Wallace was born in 1924, and a daughter, Marda, arrived in 1925. In her book, *Stopping the Presses: The Murder of Walter Liggett*, Marda concluded that her father may have been nostalgic for small-town life, and after years of barnstorming from coast to coast as a muckraker, he turned his attention to the plight of farmers in a down-turning economy and the resurgence of the Farmer-Labor Party in his home state of Minnesota.

In 1930, Floyd B. Olson was elected governor of Minnesota as a Farmer-Labor Party candidate. The Farmer-Labor Party was on the move in those days. By 1932, the Farmer-Labor Party, together with its associate clubs and F-L associations spread throughout the grain belt, had grown to make up about 15 percent of the electorate in the entire country—a fact that is almost completely unknown and forgotten today. It was, by far, the largest third-party formation in America in the twentieth century.

Although Walter Liggett was wary of Olson's past record in failing to prosecute the gangsters who ran liquor, he was willing to give Governor Olson the benefit of the doubt, having received reports from old Farmer-Labor friends in Minnesota that Olson had turned a new leaf. In 1933, Walter made the decision to move his little family back to Minnesota, hoping

to help build the Farmer-Labor Party into a viable national force. Upon arriving in the Twin Cities, he met with Governor Olson, who welcomed him "on board." Then he moved his family to Bemidji, Minnesota, where, for a while, he worked for the *Northland Times*, focusing on the wholesale foreclosures and tax evictions occurring at an increasing rate.

Later, in 1933, he moved to Austin, Minnesota, and in 1934, to Rochester, Minnesota, where he set up shop as the editor of his own newspaper, the *Midwest American*. He had boundless energy and worked long hours. The course of Walter Liggett's gradual disillusionment with governor Olson, after his return to Minnesota, took a while to fully mature into open "insurgency." But when it did, it came in the context of a full-blown revolt of a whole faction of Farmer-Laborites, who were inspired and led by A.C. Townley, the man who started the Nonpartisan League back in 1915.

The radicals in the party were responsible for the impetus that produced the platform drafted at the party convention in the spring of 1934, the platform that, in response to the recent repeal of Prohibition, called for "state-owned Liquor dispensaries." At that point in time, there were grumblings among the rural rabble about Olson's "All-Party" favoritism.

The incident leading to the "Townley-Liggett Revolt" took place in late August 1934, when it was announced that Floyd Olson had chosen, as the campaign manager for his 1934 reelection campaign for governor, a man by the name of John Hougen, a Twin Cities lawyer, who was a notorious fixer for the local "bipartisan party bosses" of both the Republican and Democratic Parties. The insurgents, called together by A.C. Townley, met at the Armory in Benson, Minnesota, on Labor Day 1934.

THE FASCINATING FLOYD B. OLSON

Floyd Bjørnstjerne Olson is a fascinating study of good and not so good. He grew up in North Minneapolis in a run-down neighborhood of tiny shacks and brothels. Many of his boyhood friends grew up to be police officers complicit in the movement of illegal liquor through the Twin Cities during Olson's tenure as Hennepin County district attorney from 1920 to 1930. Olson left Minnesota after dropping out of the University of Minnesota and headed west, joining the Industrial Workers of the World (IWW) union as a dockworker. He returned to Minnesota in 1913, completing a law degree at Northwestern College of Law, currently the William Mitchell College of Law. Surprisingly, Olson, who generally voted as a Democrat, was appointed district attorney of Hennepin

An article by Walter Liggett about Howard Guilford, a newspaper editor who was murdered before Liggett after writing exposés about Minnesota governor Floyd B. Olson's ties to the mob. *Courtesy of Mark Evans.*

County by the Republican administration, beating out a number of members of the Republican Party vying for the coveted position. Olson served previously as assistant county attorney under William "Bud" Nash, a crooked judge who bragged of being a former bootlegger and brothel owner. Nash was removed from his position when investigative journalist Howard Guilford brought into daylight Nash's acceptance of bribes from gangs and gunrunners, inspiring a letter-writing campaign demanding his removal.

As county attorney, Olson perfected plea-bargaining and suspended sentences, allowing nearly one thousand felons off the hook between 1925 and 1928, alone. On the other hand, he fiercely opposed anti-labor, anti-Semitic and white supremacist factions.

Olson served as governor of Minnesota from 1931 until 1936, when he died of stomach cancer at the Mayo Clinic in Rochester, Minnesota. In spite of his questionable work as county attorney, Olson is remembered as one of the greatest governors our state has seen. Though opposed by the right, Olson was successful during the harsh economic conditions of the Great Depression in creating social security as a safety net for families, expanding environmental conservation programs, guaranteeing equal pay for women and making collective bargaining a right. He also instituted minimum wage and unemployment insurance, focusing on the welfare of those who elected him governor.

Olson is also remembered for invoking martial law and threatening dictatorship during the labor strikes of the 1930s. From the steps of the state capitol, Olson stated in 1933:

Minnesota Blind Pigs and Bootleggers

I am making a last appeal to the Legislature. If the Senate does not make provision for the sufferers in the State and the Federal Government refuses to aid, I shall invoke the powers I hold and shall declare martial law...A lot of people who are now fighting [relief] measures because they happen to possess considerable wealth will be brought in by provost guard and be obliged to give up more than they would now. There is not going to be misery in this State if I can humanly prevent it...Unless the Federal and State governments act to insure against recurrence of the present situation, I hope the present system of government goes right down to hell.

In the 1930s, the local "forces of reaction" accused Floyd Olson of promoting socialism during his tenure as governor. Granted, Olson was a complex and somewhat convoluted individual. As a Farmer-Labor governor and sometimes sincere "populist," he may actually have left the poor and middle class in Minnesota better off. Yet his legacy has been marred by accusations of collusion with the local godfather, Meyer Schuldberg, and capo, Kid Cann, of the A-Z Syndicate, also known as "the mob," which was run (in the 1930s) from the top floors of the Waldorf-Astoria Tower in New York City.

Kid Cann, born Isadore Bloomenfield, a Jewish immigrant from Romania, grew up in Olson's old neighborhood of north Minneapolis. Two of the dead journalists who persisted in making this connection—the "right-wing muckraker" Howard Guilford and the Farmer-Labor "insurgent" Walter Liggett—both died "with their boots on" and paid the ultimate price for their efforts to expose the ties between the popular governor and organized crime.

It is important to remember that Congress (at the urging and instigation of President Roosevelt) repealed Prohibition in December 1933. That very same month, the A-Z Syndicate, aka Murder, Inc., was organized in New York City as a coast-to-coast corporation, a peculiar kind of union of former rumrunners gone "legit." As a clearinghouse and labor pool of crime, it was never exclusively either Italian or Jewish. Nor should it ever have been called the "Mafia" or the "Cosa Nostra."

That myth was always the convenient cover story to protect the power elite who ran the damned thing. From the very beginning, the mob was never more than a dirty cutout for black ops done by, and in the interests of, the plutocracy. The boogeyman of greasy Sicilians was never more than a scare tactic and a shill to take the heat off the men who were pulling the actual strings and ordering who was to be "rubbed out" by their creature, Murder, Inc. The bosses who presided over it were all proper men of business and finance who had their offices on the top floor of the Waldorf-Astoria Tower in Midtown Manhattan.

MUCKRAKERS

As a result of the "open door" policy of harboring freelance bank robbers like Baby Face Nelson, Ma Barker and her gang and John Dillinger, as well as better-connected and more prosperous gangsters—protected operators of rackets like Kid Cann, who were privileged members of the Syndicate—the Twin Cities were crawling with underworld figures. It appeared that justice could be sold to the highest bidder under Olson's watch.

As a rule, the newspapers of the day—the *Twin City Reporter*, the *Saturday Press*, the *Pioneer Press* and the *Beacon*—steered clear of reporting ties between the law and the mob. During the Great Depression, and specifically during the period of the famous Teamsters' Strike of 1934, the journalist Howard Guilford, a staunch "conservative" with probable ties to the Citizen's Alliance and the reactionaries, was not afraid to take on Governor Olson and expose what he knew of Olson's ties with organized crime. Guilford had never been a fan of Floyd Olson or a member of the Farmer-Labor Party, and there was never any love lost between them.

The violent death of Howard Guilford at the hands of the underworld— coming, as it did, just a few days after the insurgents of the Farmer-Labor Party met at the Benson Armory at the instigation of their old standard-bearer, A.C. Townley, on Labor Day 1934—was another inciting incident that further radicalized Walter Liggett, pushing him down the path of taking on governor Olson and leading him, reluctantly, to examine the charges that Howard Guilford had been leveling against the governor.

RADICALS AND INSURGENTS IN MINNESOTA

The real significance of Walter Liggett's fifteen-month campaign against Governor Olson in the pages of his newspaper, the *Midwest American*, which ended in the machine gun murder of Liggett at the hands of the Syndicate, lies in the nature of a family feud, or "infighting," within the Farmer-Labor Party.

As Edith Liggett explained, the Farmer-Labor Party platform of 1934 called for "state-owned liquor dispensaries—as have been successfully established in Sweden." One faction of the party—the rural, hayseed, historically "dry" during Prohibition faction—wanted to implement the platform. This was, essentially, the "Farmer" faction within the "Farmer-Labor" equation, and it is important to keep in mind that the Farmer-Labor Party was, from the beginning, an amalgam of two elements.

This was the constituency that A.C. Townley called together to meet at the Benson Armory on Labor Day 1934. Known to the world, and the reading public, as the insurgents within the Farmer-Labor Party, they styled themselves as the "old wheel-horses" of the Nonpartisan League, since most of them were older and had been in the struggle from the time the league jumped the state line from North Dakota during the Great War.

As the rural advocates of a peculiarly Scandinavian form of socialism, they were, paradoxically, both economically radical and culturally conservative at the same time. Many of them had been for Prohibition at the beginning, in 1919. Yet when Prohibition was shown, in practice, to corrupt good government, they turned reluctantly to favor repeal. The one thing they did *not* want was for the former rumrunners to be given the control of the new, legalized liquor market. Both as socialists and moral, family-oriented folks who saw bars and saloons as places of corruption, they believed that the control of the trade belonged, properly, to the province of the state.

The other faction of the Farmer-Labor Party, according to Edith Liggett, was, quite simply, Governor Olson's machine, which those in the know, the cognoscenti of the insurgency, referred to as Olson's "All-Party Machine," since Governor Olson had very adroitly packed his whole administration with hard-boiled political spoilsmen of both the Democrat and Republican persuasions, as well as his own hand-picked, city-bred "Farmer-Labor" loyalists.

This faction was, as Edith put it, "soaking wet." Indeed, most of them were heavy drinkers themselves, especially those who considered themselves fortunate enough to vacation with the governor himself at his digs at Breezy Point Lodge on Pelican Lake.

This faction of the Farmer-Labor Party had very little interest in implementing the platform of 1934, either as it applied to nationalizing the Federal Reserve System or when it came to instituting a state bank, like the Bank of North Dakota, which has, incidentally, over the years made the citizens and farmers of the state of North Dakota very prosperous. They were especially not interested in implementing the plank of the Farmer-Labor platform that called for state-owned liquor dispensaries.

Being "realists," what they wanted was to collect hefty contributions from the nascent Liquor Lobby, aka "the Syndicate," to fill Governor Olson's campaign finance chest. In point of fact, most of them, from the governor on down, considered the platform of 1934 to be an embarrassment imposed on them by the radicals, the left wing of the party, during the party convention in the spring of 1934. And it was so.

And what did the Liquor Lobby want? With plenty of trucks, access to an unlimited supply of booze and lots of quasi-legal, protected rackets that brought in plenty of money, it regarded itself as the natural custodian of the trade it had plied during the years booze had been illegal. Consequently, it wanted only to continue to run liquor, man the saloons and profit from the new liquor stores it intended to open—since repeal had now made its members legitimate businessmen. And it did not especially appreciate those brave souls, like Walter Liggett, who were valiant for the Farmer-Labor platform and its ridiculously idealistic plank about state-owned dispensaries, since it threatened the Liquor Lobby's future business ventures.

MURDER

Thus, the last year and death of Walter Liggett, who took up the cudgels against Olson after the death of Howard Guilford, possess the nuance of a different struggle in that Liggett's motives—and his associates—differed from those of Howard Guilford and must be seen in the context of a factional fight within the Farmer-Labor Party itself. Liggett published his own newspaper, which detailed the ongoing relationship, after the repeal of Prohibition, between the Liquor Syndicate, the former "rumrunner of Prohibition days"; its capo, the gangster Kid Cann; Olson's campaign fund treasurer, O.J. Fosso; the First Bank crowd; and the popular, populist governor Floyd B. Olson himself.

Liggett's newspaper, the *Midwest American*, with all its intricate web of details picturing the world from the Minneapolis of 1935, is still available on Microfiche from the Minnesota Historical Society in St. Paul.

AN EXCERPT FROM *LIGGETT, THE SCREENPLAY*

By Mark Walter Evans, Liggett's grandson

FADE IN: ON SCREEN—A NEWSPAPER MASTHEAD:

THE MIDWEST AMERICAN
News the Daily Papers Don't Dare Print

Impeachment of Olson
Is Justified by Record
Subtitle: December 6, 1935

Int. Public Library, Minneapolis—Day

Subtitle: Minneapolis, Minnesota
Dec. 9, 1935, 4:55 p.m.

Marda Ligget, a red-haired girl of ten, sits at a table reading "THE GREEN FAIRY BOOK."

Presently, Marda's father, WALTER LIGGETT, newspaperman, a big, balding man of forty-nine, enters. Knowing it's time to go, the little girl puts the book back on the shelf. Walter playfully hugs his daughter, wraps her in her coat.

LIGGETT
Bundle up, it's gotten cold again.
 He warmly holds her hand as they leave.

EXT. LIBRARY—DUSK
A light coat of snow covers the ground. They walk down the Library steps. A car is waiting.

INT. LIGGETT'S FORD CAR—DUSK

Walter Liggett climbs into driver's seat. A.B. GILBERT sits in the passenger seat. Marda joins her mother, EDITH LIGGETT, in the back.

A.B. GILBERT
This sure is a cold year.

LIGGETT
We have to make do.

Liggett starts the car—it is cold, and takes a little while to ignite the spark, and they drive.

EXT. SWENSON'S MARKET, MINNEAPOLIS—DUSK

Liggett double-parks on the street. Marda goes inside, finds a labeled box of groceries on floor. A.B. Gilbert goes in with her, carries them out. ON RADIO—"WALKING IN WINTER WONDERLAND."

INT. LIGGETT'S CAR. DRIVING DOWNTOWN—DUSK

The little girl closes her eyes, and leans on her mother.

A.B. GILBERT
Sorry I can't be in St. Paul, tomorrow, to hear your speech before the Legislature.

LIGGETT
When I'm done, they should impeach him, hopefully…

A.B. GILBERT
It won't be easy. I wish you luck, Walter.

LIGGETT
(Laughs)
Thanks—because I'm going to need it.

INT/EXT. LIGGETT'S CAR, BUS STATION, MINNEAPOLIS—NIGHT

The car stops. Gilbert climbs out. They all wave goodbye. Liggett drives off.

EXT. SIXTH AND HENNEPIN—NIGHT

Liggett parks again, and climbs out to buy a copy of THE NEW YORK TIMES. *He hands it to his wife.*

MARDA
Such a big, boring paper.

Liggett drives on. Night begins to fall.

EXT. LIGGETT APARTMENT, ALLEY—NIGHT

He parks the car.

INT. LIGGETT APARTMENT—NIGHT

Minnesota Blind Pigs and Bootleggers

Twelve-year-old Wallace was in the second-floor apartment facing the alley when his father, Walter Liggett, was killed by Tommy gun fire.

WALLACE LIGGETT, twelve, Marda's brother, sits in an easy chair, drinking hot chocolate, and listening to "JACK ARMSTRONG, THE ALL-AMERICAN BOY," on the RADIO.

EXT. ALLEY BEHIND LIGGETT APARTMENT—NIGHT

Liggett exits the car, reaches back, gets the groceries.

LIGGETT
(to Marda)
Wake up, sleepy head, we're home.

The little girl opens her eyes.

At the corner, a dark Green SEDAN turns suddenly down the Alley. LIGGETT is unconcerned, but moves to allow the other car room to pass.

The shadowy PASSENGER in the front-seat suddenly sticks a MACHINE-GUN out his window. He FIRES! Bullets tear into Liggett's back, a tight crescent around his heart.

Marda, screams and ducks, in horror.

Edith, in shock, glimpses the face of the Assassin, his hideous grin.

Liggett spins like a boxer, fists up, but then falls in the street.

The sedan Speeds away.

Edith rushes to Walter. Gets on her knees, takes his hand.

Edith
Oh my God, Walter!
Marda, in shock, standing over her father.

Marda
Daddy! Daddy! Please don't die!

From the window, Wallace peers down in shock.
Marda
(Screaming up to Wallace, in window)
They shot Daddy!

Marda rushes into the house. Windows in the alley open, lights are turned on. People appear on the street. A Man takes Liggett's pulse, nods to Edith he still has one.

Walter's eyes glaze over.

Edith is close, holding his head in her lap.

Edith
Walter, Walter, Please don't die.

His eyes now close in death.

The Image of a grain of Wheat being planted in the earth is superimposed upon the Corpse of Liggett, below, on the street…

To see the entire screenplay, see the website www.paleoprogressives.org.

Aftermath

According to Mark Evans:

> *Walter Liggett's body was cremated, as per his inclination and wish. A group of friends gathered at his wake, his ashes in an urn on the table; his friends celebrated his life, and a Victrola record player played a 78 of "The Blue Danube," which was the only tune that he had been able to recognize, in life, since he was very tone deaf. I do not know what subsequently became of his ashes—whether they were scattered on Wood Lake, in Wisconsin, on one of the lakes around the Twin Cities or in the Mississippi River.*

Edith was a brave woman, with courage to match her husband's, and she was fully determined, after he died, to continue the fight, until Olson was driven from office and the insurgents took back the reins of the Farmer-Labor Party. She left Minnesota, with some regrets, in the spring of 1936, for several very legitimate reasons.

First, there continued to be anonymous phone calls threatening the kidnapping and murder of her children. She knew from experience that those guys meant business. Then there was one instance when, while she was crossing the street near the *West Lake Neighborhood News/Midwest American* printing office, a speeding car attempted to run her over—and the same thing also happened to a female friend, who closely resembled Edith.

Further, Edith was sickened by the hoopla and partying that took place after Kid Cann was acquitted. Prominent Democrat and Farmer-Labor Party politicians and police officials were present, and there was much liquor drunk and much celebration. Then, after it was learned that Floyd Olson had stomach cancer and was dying, some of the more serious and prominent Farmer-Labor officeholders who had sympathized and agreed with the aims of Townley and the insurgents that a "house-cleaning" was in order (to eliminate Olson's "All-Party Machine") began to back peddle and retreat from the insurgence, seeking mild reconciliation with the pro-Olson ranks in the party.

By 1938, from her vantage point in Brooklyn, Edith was very pessimistic about the whole scene in the Midwest—particularly concerning what she had suffered and what had transpired. She noted in her journalism that Charlie Ward (whom she had publicly accused of being the local paymaster for her husband's assassination) continued to buy politicians and that the LaFollette brothers had come under his financial wing. Charlie Ward, by

the way, was the financial uncle for that up-and-coming druggist/politician Hubert H. Humphrey, who managed to broker the amalgamation—and assimilation—of the Farmer-Labor Party into the Democrat Party in 1943 in preparation for his run for mayor of Minneapolis in 1944, thus fulfilling Walter's great fear that the movement would be "sold down the river" to the Democrat Party, just as Bryan had done with the Populist Party back in the 1890s.

IN RETROSPECT

Mark Evans notes:

By 1960, when Edith laid the burden of history on this tender lad of ten, she told me tearfully, "You can't fight city hall." My mother, who loved her father dearly, always resented the fact that he had given up his life in the struggle against Olson and the Syndicate. She wanted, and needed, a father—and he was gone.

From my standpoint, I also think that Walter would have been wise to have heeded Edith's admonitions to return to New York City and to continue the fight from there—but then, perhaps he already knew too much, and his days were numbered anyway. As Edith told me, in 1960, the people who ordered the hit had their offices on the top floors of a couple of sky-scrapers in New York.

9

LEON GLECKMAN, ST. PAUL'S AL CAPONE

Leon Gleckman ran St. Paul in the late 1920s and '30s, and all it took was a little money in bribes and a winning personality. The money was, of course, from the sale of illegal liquor during Prohibition, which made him wildly wealthy by the standards of the 1920s and '30s. He controlled the businesses of illicit liquor and gambling in the state's capital. His control over the city was due, in part, to the generosity he extended, helping friends win coveted positions on the police force and influential positions within government offices.

Gleckman immigrated to St. Paul as a child from Minsk, Russia, and was raised in a strict Jewish household. Gleckman was a born salesman with a special gift for selling bootleg liquor. He married young and had three little girls. He supported his family well on proceeds from the Minnesota Blueing Company, a shell business consisting of over a dozen stills and profits exceeding $1 million a year.

On March 26, 1926, a *New York Times* headline screamed, "112 Men Indicted in Alcohol Plot. 164 Overt Acts in 12 Cities Cited, with Handling of 375,000 Gallons of Alcohol."

Leon Gleckman was among the 112 arrested in the trafficking crime, illegally transporting seventy-five carloads of pure grain alcohol. Other criminal offenses included the exchange of money for the purchase of illegal alcohol, bribes for protection from officials and the storing of contraband liquor. The conspiracy originated with four Philadelphia men and spread across the Northwest, Pacific Coast and Midwest to include the "Twin Cities million-dollar rum ring," located in Minneapolis and St. Paul, with a subsidiary in

Duluth. The article also cited the "crime of protection" by a police detective in St. Paul, naming Detective Thomas Brown in the plot. Officer Brown headed up the purity squad in St. Paul during the early 1920s, an organization that had a penchant for sledge-hammering slot machines if the photographs on the Minnesota Historical Society website, www.mnhs.org, are to be believed. The vulnerable slot machines were those not under Officer Brown's protection. And though Brown's connection with Gleckman endured for years, now retold as part of the local legend, the charges were subsequently dismissed.

A year later, on September 22, 1927, a *New York Times* article announced secret indictments against twenty-nine persons in five states—including Minnesotans Morris Roisner, Harry Gilman, Leon Gleckman, Tom Weber, Morris Miller, Nathan Bader, George Hurley, Samuel Harris, Abe Ginsberg and Ben Gleeman, who was serving a life sentence for murder—as "dry law violators" in connection with another alcohol plot. The indictment listed as crimes the failure to label spirituous liquor, false billing and obtaining cheap freight rates by false billing and false labeling, which consisted of plastering labels with the name of legal medicine on the sides of bottles filled with alcohol. All of the men had been included in the indictment from the year before.

THE ST. PAUL HOTEL

350 Market Street in St. Paul, Minnesota

My friend Melanie and I visited the magnificent St. Paul Hotel in downtown St. Paul, and we were charmed. We were charmed by the ideal neighborhood where the hotel holds court, observing trendy young office workers enjoying their lunches under the dappled shade of young trees. There are those who complain about St. Paul not being laid out in a perfect grid (Governor Jessie Ventura got into a whole lot of trouble mentioning it—but then I believe he included the phrase "drunken Irishmen" in his good-natured statement), but it is precisely this quality, along with the old architecture and grassy spaces, that makes St. Paul one of my favorite places to visit.

When we entered the hotel, I had to stop and just feel it. I was dazed by the beauty of the pillars, the furnishings and the fabulous chandeliers. Melanie and I were visiting the hotel to get a sense of the place where Leon Gleckman, a moon-faced gangster, conducted his operations from the third floor during the 1920s and '30s. I have to hand it to him: Gleckman had great taste. In the lower level of the hotel was a speakeasy,

run, during the Prohibition era, by Gleckman. Liquor was delivered by local bootleggers right to the front door at the circular drive of the hotel.

The hotel is one hundred years old, and she's never looked better. I'm wracking my brain to come up with a reason I need to stay there. This hotel has hosted presidents, celebrities and foreign heads of state. George W. Bush, John F. Kennedy, Bill Clinton and Theodore Roosevelt have all laid their heads on pillows in the St. Paul. But they weren't they only guests of distinction. Heads of state from Norway, Sweden, Ethiopia and Japan have enjoyed hospitality here. Oh! And let's not forget about bandleader Lawrence Welk. Uh-one, uh-two, uh-three...It

Gangster Leon Gleckman occupied the third floor of the St. Paul Hotel in St. Paul, Minnesota.

is, hands down, the most opulent building I have had the opportunity to set foot in.

The hotel hosts a variety of events. Perhaps Melanie and I will take in a Saturday afternoon tea, where we will sip with our pinkies raised and act like ladies. But then, we could just as easily get the giggles and snort tea out of our noses, which I have been advised is considered bad form. Or maybe, just maybe, when my book is released, the St. Paul Hotel will host a book signing.

What? It could happen.

—Minnesota Country Mouse

Gleckman was sent to Leavenworth Prison, where his first course of action was an attempt to bribe the prosecutor. In his book *John Dillinger Slept Here*, Paul Maccabee located a report from Leavenworth Prison, placing Gleckman's intelligence and problem-solving skills in the ninetieth percentile of prisoners, an impressive yet dubious honor. Gleckman was released from Leavenworth in 1928 and returned to St. Paul to take over the city.

By all accounts, Gleckman appeared to be a family man, enjoying the company of his wife and children. While Gleckman's liquor business flourished in the underworld, he laundered the profits through his auto loan business, Republic Finance Company, of which he was president and stockholder. He drew a salary from the business, along with rent from properties he owned. He filed his taxes based on the usual type of income that a typical business owner would receive.

On September 24, 1931, Gleckman was abducted from his home in St. Paul, and a ransom demand of about $200,000 was reportedly made to Gleckman's business partner, Morris Roisner. The amount paid to the kidnappers eventually dropped to $6,400. According to Paul Maccabee's research, which included FBI files, the ransom was delivered to the kidnappers by Jack Peifer, owner of the Hollyhock Casino at 1612 East River Road, who once had a shipment of bootleg liquor highjacked by Gleckman's men, resulting in death threats made to Gleckman by Peifer.

One kidnapper reported later, during his stay at Stillwater Prison, that Peifer was the mastermind behind the kidnapping scheme, but the kidnappers had been warned by chief of police Tom Brown not to mention Peifer if they knew what was good for them.

Stories vary about the murder of Frank La Pre, who was keeping the ransom money in a safe in his hotel room. The story that appears to be the most corroborated was that police chief Tom Brown, Gleckman's close friend, actually killed La Pre then had his men arrest the remaining kidnappers after presenting his men with a list of names supposedly beaten out of La Pre shortly before his murder. The ransom eventually found its way into Chief Brown's war chest when he unsuccessfully ran for Ramsey County sheriff. The official story, carried by the *New York Times* on October 4, read as follows:

> *KIDNAPPERS KILL AIDE*
> *Following Murder, St. Louis Abductors of Leon Gleckman are caught.*
>
> *ST. PAUL, Oct. 4—The kidnapping of Leon Gleckman, St. Paul politician and finance company head, had its aftermath today in the death of one man and the arrest of four others who, Police Chief Thomas A. Brown said, confessed the abduction.*
>
> *Fears that their contact man would "squeal" on them, Chief Thomas A. Brown said, prompted the four, who kidnapped Gleckman for $200,000 ransom and got only $6,400, to slay Frank La Pre last night.*

Police found his body early today, his skull bashed in and his head perforated by a bullet, by the roadside four miles from town.
Several hours later, about forty men and women were in jail, including the four Brown later said confessed to the kidnapping. One Sam Cimin, who had served time for violating the prohibition law, he accused of doing the actual slaying.

Little Florence Gleckman, Leon's daughter, was kidnapped in 1932 but was safely returned home without her kidnappers collecting the $50,000 ransom demanded. Even criminals have their standards, and Gleckman put kidnapping at the top of the worst crimes committed list, calling it "the lousiest crime in the world."

Now, About Those Taxes

Federal agents were fed up with Gleckman's hold on the city of St. Paul and began looking for a way to loosen his grasp. One of the most effective ways to do that would be to send him to jail on tax evasion charges. By 1934, a precedent had been set on the taxation of illegal liquor, and even though the prohibition of liquor was repealed in 1933, there was a matter of back taxes.

As a precedent for going after Gleckman, investigators noted that in 1925, the first case of a bootlegger, former New York lawyer Charles J. Steinberg, was convicted of hiding taxable income from the illegal sale of liquor. The Bureau of Internal Revenue claimed in the case that it had long since ruled that all incomes, whether derived from bootlegging, burglary, gambling or blackmail, are subject to income tax. Two years later, on May 17, 1927, the Supreme Court ruled that earnings from bootleg liquor operations were properly taxable under the federal income tax law.

In another case brought before the Fourth Circuit Court of Appeals, defendants argued that illicit liquor was taxable but that the Fifth Amendment to the Constitution protected them from the necessity of making a return. The court ruled that, to the contrary, a taxpayer was *not* relieved of the requirement to declare earnings that might bring him in conflict with the Prohibition laws: "We see no reason to doubt the interpretation of the act or any reason why the fact that a business is not lawful should exempt it from paying taxes that, if lawful, it would have to pay." It was the court's opinion that the argument based on the Fifth Amendment was "stretched too far."

The opinion continued, "It is urged that if a return were made, the defendant would be entitled to deduct illegal expenses, such as bribery. This

An inkwell from the Foshay Bank, where St. Paul gangster Leon Gleckman banked. The inkwell is a relic from the Foshay Tower Museum in the W Minneapolis Hotel, Minneapolis, Minnesota.

by no means follows, but it will be time to consider the question when a taxpayer has the temerity to raise it."

Gleckman found himself in court, being tried under the same precedent as *Capone v. United States* (56 Fed. [2d] 927). He was accused of willfully attempting to evade income taxes for 1929 and 1930 by making false returns for those years. Prior to 1926, Gleckman had not filed income taxes, but in 1928, he filed taxes for 1925, 1926 and 1927, stating that he made $15,000.00 each of those years and paid taxes based on that figure. In 1929, after deductions, interest payments and charitable contributions, Gleckman paid the total tax due of $49.02. In 1930, he paid $185.57. The government assigned the task of reviewing Gleckman's bookkeeping to an auditor named Mr. Schall, but Gleckman had no documents to provide him with. Gleckman banked with the Foshay State Bank and the Commercial Bank in St. Paul, and the auditor—and Gleckman's bookkeeper—secured deposit slips. Gleckman also reported earnings under the assumed name Abraham Wynehouse at the Journal National Bank, New Jersey City, New Jersey. After much deliberation, it was determined that the tax bill due was in the amount of $30,174.00.

Gleckman's tax trial in 1935 resulted in the Internal Revenue Service formally creating the bank deposit cash expenditure method of investigation, which continues to be used today, most often for surveillance of tipped employees using statistical analysis to determine a tipped employee's actual wages.

In 1938, Gleckman appealed charges of a felonious attempt to defeat and evade income taxes due the United States for the calendar years 1929, 1930 and 1931, and in addition, he was appealing charges of willful, corrupt and contemptuous misbehavior for bribing a juror named Bernard A. Fuchs with $695 to vote not guilty, thereby causing a mistrial.

WABASHA STREET CAVES

215 Wabasha Street South in St. Paul, Minnesota

It comes back to me as a sort of dream. Ed and me sitting at a table together in a room full of frenetic energy and blare, watching dancers whirling around and getting tossed in the air while a big band played brassy music from the swing era. You know, back when jazz was king, or however they say it.

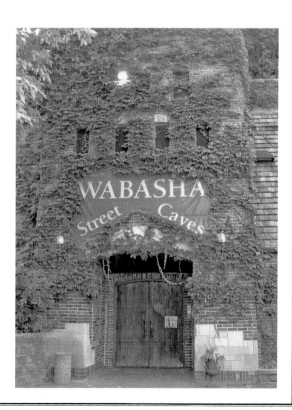

The Wabasha Street Caves (Castle Royal) at 215 Wabasha Street South in St. Paul, Minnesota.

His company was hosting a Christmas party, which we were invited to, at the Wabasha Street Caves, and I knew the moment I walked in that a whole different generation of people had once celebrated here. I could feel the still-lingering, hyper-energized atmosphere of people partying till hell wouldn't have it. And I could almost see them, like looking into a cloudy antique mirror.

The caves, originally dug for silica, which is an ingredient used to make glass, and then utilized as a space for growing mushrooms in the 1800s, eventually morphed into a speakeasy during Prohibition. At Prohibition's close, they became a nightclub called the Castle Royal, which featured a sixteen-hundred-square-foot dance floor, casino, dining room, fireplace and the whole shebang.

Villains like Baby Face Nelson, Machine Gun Kelly, John Dillinger, Ma Barker and her boys and Dapper Dan Hogan all were believed to have enjoyed the caves during Prohibition. Legend holds that a card game in the fireside room in 1934 ended with a blast of machine gun fire and three men dead on the floor. When a cleaning lady accidentally stumbled upon the bodies, she quickly ran to get the police. But when she and the officers returned, the bodies and blood were gone, and the room was neat as a pin. The only remaining evidence of the crime were pockmarks left in the wall from machine gun fire. The property exhibits paranormal activity, and it is believed that the bodies were dragged to another part of the cave and buried beneath debris from floods, deposited there during cleanup decades before.

The Prohibition years live on at the Wabasha Street Caves, with gangster tours every weekend highlighting the homes and businesses from St. Paul's wild adolescence. Thanks to Ed, I had a chance to experience the caves and hold the memory as a precious thing because it was with him, a man who crossed over to the other side with seven years of my affection in his back pocket, on a cold winter day on a lonely farm in southwestern Minnesota. Ghosts and gangsters. Kind of makes you feel all warm and fuzzy inside, doesn't it?

—Minnesota Country Mouse

During the retrial of the tax evasion case, Fuchs was paid $125 to corruptly influence a juror named Mrs. Gilbert J. Henke. The two cases were consolidated, and Fuchs appeared as a witness for the government. Here's how the story played out. In April 1934, a woman named Mrs. Rose Helen Harper was employed in the office of commissioner of parks and playgrounds for the City of St. Paul. Fuchs, who was an accountant, was setting up a cost accounting system for the commissioner, working at a desk a few feet from Mrs. Harper, who had been helped into her job by Gleckman.

St. Paul Hotel, 350
Market Street, St. Paul,
Minnesota.

Fuchs, an employee of the Federal Land Bank of St. Paul in 1934, was called
as a juror in the Gleckman tax evasion case, and Mrs. Harper contacted him
and told him she wanted to do everything she could to help Mr. Gleckman.
She gave him $20 and a pint of liquor, promising that there would be an
additional $300 if he voted in favor of Gleckman. During deliberations by
the jury, Fuchs pulled out the bottle and passed it around. The final ballot
stood nine to three for acquittal, and the jury was discharged. Later that
evening, Harper and Alexander (Jap) Gleckman stopped at Fuchs's house to
tell him he did a good job and paid him the promised $300.

During the trial, Harper and Jap were observed by special agents of the
Intelligence Unit of the Treasury talking to both Gleckman and members of
the jury. At one point, court officials had asked Jap not to stand so close to the
jury box. A new trial was set for November 12, 1934. Court records indicate
that during the trial, both Gleckman and his brother, Jap, kept rooms (306 and
308) at the St. Paul Hotel, the same hotel where the jurors were being lodged.

After the trial, Fuchs visited Leon Gleckman at the Republic Finance
Company, located in Suite 713 of the Merchant's Bank building, and advised
him of what had taken place while the jury deliberated, making a point of his

The former Lowery Hotel in downtown St. Paul, Minnesota.

support of Gleckman and thanking him for the $300. Fuchs went on to request a loan of $300, the amount recently denied by Gleckman's son-in-law for lack of collateral. A loan for $250 was arranged. Gleckman later provided Fuchs with an additional loan of $50 and had a conversation with him about the second trial coming up. Gleckman asked Fuchs if he was familiar with Mrs. Henke, who worked at the Federal Land Bank and would be sitting on the jury.

Fuchs was not familiar with her but said he would go to the court and listen to the trial. While there, his stares at Mrs. Henke unnerved her so much that she turned her face away. Fuchs was asked to leave the courtroom. Police records showed that Gleckman had placed a phone call to the room Fuchs was occupying at the Lowry Hotel. The second trial resulted in a conviction.

In July 1941, while waiting to serve his prison sentence, Gleckman slammed his car into an abutment at Kellogg Boulevard and Wacouta Street, near the St. Paul Depot Bar, fracturing his skull. His blood alcohol level was extremely high, and although it appears the collision was an accident, according to MacCabee's book, the death certificate listed the cause of death as "probably an accident." The reign of Gleckman was over.

REDWOOD FALLS BANK HEIST

BARKER-KARPIS HOSTAGE STORY

By Mona Leavens

September 23, 1932. In the bank at the time: Art Hassenstab, Earl Whiting, Gerald Engeman, "Pete" Peterson, Mona Leavens.

It was a typical bright September morning. I came into the bank at 9:00 A.M. and went at once to the Post Office for the mail. I returned to the bank and laid my purse on my desk with the mail. Was about to take off my coat when I heard the gate leading to the officers' desks on the east side of the bank slam very hard. Looked up to see a man coming toward the work counter with a gun in both hands. At the same time another man entered from the west side and said, "This is a hold-up. Do as you are told and no one will get hurt." We did.

They told us to lie on the floor. A man stood over us with a gun. One of the boys raised his hand and the man told him to keep his hand down or else. Don't know how long we laid there but it was perhaps five or ten minutes. Then they indicated that Art and I should get up and told the other three to stay there for ten minutes. They herded Art and me through the back door (sealed up after the hold-up) toward a car, said to be a late model, blue Buick. They told us to get on the running boards of the car on either side. They had, according to an eyewitness, carried out the "loot" in grain sacks which seemed to be common practice with them. No one seems to know why.

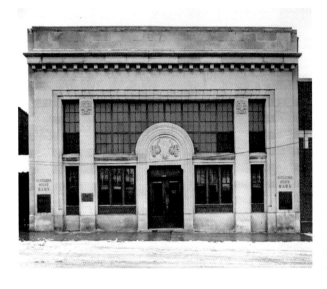

Citizens State Bank, robbed of $35,000 by the Barker-Karpis Gang in 1932. *Photo courtesy of Gary Revier, Redwood Falls, Minnesota.*

Mona Leaven's first-person account of her abduction from the Citizens State Bank of Redwood Falls during the September 23, 1932 bank robbery by the Barker-Karpis Gang. *Courtesy of Gary Revier, Redwood Falls, Minnesota.*

The man who had entered from the west side drove. He held on to me with one hand and drove with the other. Just before we started I thought I might as well look at them and lowered my head and looked in the car. The man said, "Keep your head up. Don't try to look at us." Art and I were the tallest and our heads would be well above the top of the car.

It was the oddest thing. My friend Melanie and I were driving around the Twin Cities, navigating snow banks and looking for sites where significant historic criminal events took place back during Prohibition. I snapped a few photographs. We were referring to Paul Maccabee's book, John Dillinger Slept Here, *to find our way around, and I noticed a little gray map of Minnesota with dots marking where the Barker-Karpis Gang had robbed banks around the state. And there, smack dab on Redwood Falls, was a dot. Why didn't we know this? Mel and I both lived in the Redwood Falls area for years. I said to Melanie, "I have to get in touch with [historian] Gary Revier right away to see if he knows anything about the bank robbery."*

Now here is where this gets very, very strange. In my e-mail, not twenty-four hours later, was a photograph of the very bank the book was referring to, with a note from Gary explaining about the robbery. He didn't even know I wanted it. Such synchronicity! As a rule, Gary sends historic photos to those who are interested on a daily basis, but still, what are the chances? So I e-mailed him immediately to see if he had any press released, and you're not going to believe this, but he had, in his possession, four typed pages of a firsthand experience of a young woman named Mona Leavens who had the unique experience of being a human shield for the Barker-Karpis Gang. The pages were yellowed with age, but the letters were still legible. Thank you Gary, and thank you Mona, wherever you are…

—Minnesota Country Mouse

They drove very careful west in the alley to Mill Street; one-half driveways to the McGovern home and the Rahn farm. The man on my side said, "Get off and don't look back to see which way we go." Art for some reason did not get off soon enough to suit them and the fellow on his side said, "Get off you son-of-a," which was the only rough talk I heard during the entire proceeding. We got off and started walking back. Needless to say, we did not look back. As we neared the corner of Ramsey and W. 11th we saw W.L. Pettis leaving what was then the Duncan home and Art hailed

him and told him what happened. He drove us back to the bank and the resulting confusion.

I hardly got in the door before someone from the *Gazette* came in and said I was wanted on the telephone. A Minneapolis or St. Paul reporter started asking questions. I did not know if I was supposed to talk and was still sort of shook-up so I said I did not want to talk. Boy did that guy put words in my mouth. When the paper came out it was quite an interview and not much truth in it.

Very soon the place was swarming with reporters, detectives and insurance men. The loss amounted to some $35,000. None of it was ever recovered and the insurance companies paid. Everyone connected with the bank was, of course, suspected of being involved in some way. They finally decided we were all good, hard working individuals but I shall never forget the questioning by first one and then another.

Then came detectives with suitcases full of pictures of known criminals which we were to look at and see if we recognized anyone. I asked one of the detectives what would happen if we were to identify one of them. He said, "Nothing." That in his experience, they just took it as their hard luck if an outsider identified them, but if one of their own betrayed then anything could happen.

We finally decided that one picture resembled the men who drove the car and some of us, I don't remember who, were taken to St. Paul. The authorities were very doubtful and the man was on parole from prison. He had committed a minor crime and was definitely no "big time." As soon as he spoke I was sure he was not the man who had spoken to me. He wore very cheap clothes. The man who drove the car was very well-tailored. I mentioned it and the head of the crime bureau said I was right, that the fellow was buying the suit he had on in installments. They certainly keep track of the movement of parolees.

Then the Northwestern Bank, Minneapolis, was held up, and the robbers [were] immediately apprehended and taken into custody. Some of the pictures in the paper that day resembled some of the men we had seen. So here we went again. This time it was a regular police line-up. When I saw them I could not have said, but one of our boys was quite definite about the man named "Hankins." He spent many years in Stillwater and was much in the news at the time due to get him released. Later it was proved he was in jail in a southern state at the time our bank was held-up. Certainly a good alibi. He was finally released.

That is about all. Have always felt that the aftermath was harder to take than the actual hold-up. Have always been grateful for the experience and the knowledge I gained about how these things are handled.

Odds and Ends

I only saw three men. Apparently there was one in front of the bank and one in back, neither of which I saw, or at least noticed. The gun man, who apparently was in the back was very good looking and may have been Pretty Boy Floyd. He was in the back seat of the car and I assume the two guards were also there. The man who drove the car may have been a man from a Dakota town who during the 1st World War had a record for marksmanship and when he came home his townspeople were so proud of him they elected him sheriff or something. He did something he should not have done in the

Employees of the Citizens State Bank of Redwood Falls shortly after the Barker-Karpis robbery. *Photo courtesy of Gary Revier, Redwood Falls, Minnesota.*

office, embezzled I think, and was sent to prison. There he became involved with the "big time" and when he came out became one of them. Was finally found dead in a bathtub, apparently scalded by his own cohorts. [This may have been Vernon Miller, a ruthless freelance gunman who offered his services to midwestern bootleggers and racketeers. In 1930, he teamed up with gangsters, including Machine Gun Kelly, to rob $70,000 from a bank in Willmar, Minnesota. He and his girlfriend, Vivian Mathias, spent time with other gangsters in St. Paul and Chicago.] The third man I saw was the large man who held the gun over us. Have always thought he was a man known to be a member of the same gang as the others who was finally sent to Alcatraz. When you have had such an experience there is a tendency to look at pictures and read about these things. The above is, of course, guesses. As one detective told me, sooner or later they are all caught. If not here, somewhere else.

As we were riding down the alley a good friend of mine passed. When he went home he wondered to his wife what on earth Mona was riding down the alley on the running board of a car for. You see, I was supposed to be dignified. Harold Starr, then a *Sun* reporter, passed so close I could have reached out and touched him, had I dared. Some "News Hound."

A woman and her daughter had just left the bank and were quite unhappy about it. We thought it very lucky no customers were in the bank.

During this time when bank hold-ups were so common, two girls from here were involved. Mildred Lobdell was in Northwestern Bank and Florence Evans [was] working in a Dakota bank hold-up in which the President of the bank was killed.

They [the Barker-Karpis Gang] kicked over all the wastebaskets because some banks had been hiding cash in them. They even took the money I had in my purse. Not being insured, I never got it back. About the funniest thing to me was a box into which the boys dropped the counterfeit coins that came in from time to time. They took that.

When bank hold-ups became so numerous Father Jiracek, the local priest, was in the bank one day and said to Art and me, "You folks better practice shooting." Art replied that we better practice lying down. The priest was not there at the time, but heard about it on the radio. Next time he was in town he dropped in to kid us a little, and Art told him we had done a good job of lying down without any practice.

CAPTAIN BILLY'S BREEZY POINT LODGE

THE WILFORD H. FAWCETT HOUSE

I had no idea when I was talking to my old friend Cindy that Breezy Point Lodge on Pelican Lake near Brainerd, Minnesota, would be such an interesting topic. Cindy claims it was once a favorite hangout of gangsters, and I hear that Governor Floyd B. Olson, considered by many to be the state's greatest governor, was also a frequent guest during the 1920s and '30s. Cindy tells me that in the lower level of the stately, vintage chateau called the Wilford H. Fawcett House, a speakeasy kept the guests happy during Prohibition. There was a tunnel running from the Fawcett House to the lodge, but the explanation for that, found in the *Breezy Pointer* newsletter, published since 1927, is that the house originally did not have a kitchen. The tunnel was used to ferry food from the lodge.

Fawcett ran a gambling establishment, sporting two roulette wheels with crap and poker tables, on the lower level of the lodge for the benefit of his celebrity guests. Slot machines were located throughout the main lodge. Gaming went on until a law was passed in Minnesota in 1947 banning gambling. The gaming establishment was then moved to the Farm, owned by Fawcett's close confidant and right-hand man Gene Hawkins. The Farm was eventually raided, and the era of open gambling ended for Breezy Point.

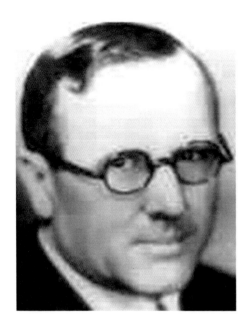

Left: Wilford H. Fawcett (Captain Billy), creator of *Whiz Bang* and Marvel Comics. *Photo courtesy of Breezy Point Lodge.*

Below: Vintage postcard of the Breezy Point Lodge. *Photo courtesy of Breezy Point Lodge.*

WHIZ BANG

So who is this Wilford H. Fawcett from Robbinsdale, Minnesota, for whom the house is named? Well, he's the founder of Fawcett Publishing, which began with a naughty little newsletter called *Captain Billy's Whiz Bang, an "Explosion of Pedigreed Bull,"* a reprinted copy of which I actually bought once, by accident,

when I was young. Years ago, just a few blocks to the west of Cindy's house, in my hometown of Wabasso, Minnesota, was a nice little drugstore called Kelly's Drug. Back then, Cindy's house belonged to my grandma, Rose, and grandpa, Arnold, and I must have been visiting them for an afternoon when I was ten or eleven, no doubt thrilled with a chance to get off the farm.

I wasn't looking for anything in particular at Kelly's Drug, and the fact that I had money in my pocket would have made it summer. Summer was the only time I had a chance to make money working out in the fields. Or maybe Grandpa had given me a few of the coins he was always jingling in his pocket and driving Grandma crazy with. Whatever the case, I was nosing around in the store and found a copy of *Captain Billy's Whiz Bang*. I thought it had a great name and that it would be sort of funny. There was a cartoon drawing of a bull on the cover.

"You don't want to buy that," said the clerk named Louie, whom I thought was one of the prettiest women in town. She attempted to talk me out of my purchase, but I stuck to my guns, and she relented. I mean, what else are you going to do with a headstrong eleven-year-old? She rang up the book for me, clearly concerned. When I got it home, I realized that she was right. I didn't want it. It had cartoons in it, but nothing I could relate to. And I knew, even at that tender age, that there was something "off" about the jokes. I stuck it on a shelf, leaving my mom wondering where it had come from.

The original edition of *Whiz Bang* was published shortly after Fawcett returned to Minneapolis from serving in World War I. The name "Whiz Bang" was a reference to a type of World War I artillery shell. Inspired by the military magazine *Stars and Stripes*, this former police writer for the *Minneapolis Journal* created what was initially a sheet of "hot jokes" on a borrowed typewriter, with his initial audience being disabled servicemen in VA hospitals. Fawcett ordered five thousand copies, which were printed on a mimeograph machine, and sent them to the hospitals and to his friends in Robbinsdale, Minnesota. The remaining copies were distributed on newsstands.

The twenty-five-cent monthly magazine was discovered by a wholesaler, which began distributing it to hotels and drugstores. *Whiz Bang*'s content was a reflection of the era in which it was published. In November 1926, it carried a poem written by journalist Walter Liggett on the topic of Prohibition in Minnesota that refers, no doubt, to Kid Cann's gang:

Ten thousand Jews were making booze
Without the state's permission,
To fill the needs of a million Swedes
Who voted for Prohibition.

Whiz Bang (May 1922) also addressed the new freedom flappers were enjoying along the lines of dress and dance:

My girl was feeling bad,
She had a terrible cough,
So she danced the shimmy
And tried to shake it off.

Does she dance badly?
Yes, if the chaperones aren't looking.

In 1933, it commented on the Great Depression:

Well, Whiz Rangers, here we are watching another year drag its tail around the corner. And what a year! The Almighty Dollar has shrunk worse than Maggie's rayon bloomers the day it rained at the Elks' Picnic; jobs have been scarcer than a stenographer on the Virgin Islands; the stock market has remained flatter than a sailor's roll after three days in port; the wets have lined up against the drys and the drys have lined up against the bars, and the only relief the farmers got was in the Smokehouse.

Fawcett's early publications carried the statement: "This magazine is edited by a Spanish-American and World War veteran and is dedicated to the Fighting Forces of the United States and Canada." Its popularity transcended war veterans, and the rag was soon delighting salesmen, sportsmen, bellhops and schoolboys. Within four years, circulation had jumped to 475,000, but by 1930, it had declined to about 150,000 as readers began to develop more sophisticated taste in magazines. Two years later, Fawcett brought his brothers, Roscoe and Harvey, into the business and broadened his magazine line to include *True Confessions*, a magazine initially featuring the real-life confessions of criminals but eventually evolving into anonymous girl-gone-wrong stories.

Fawcett introduced *Smokehouse Monthly*, a magazine "dedicated to all glorious guzzlers, woozy warblers, rakes, scallawags, and other good people who still believe in the joy of living" during Prohibition. Other magazines included *Family Circle* and those of Marvel Comics. (When I was a kid, I used to be able to buy handfuls of used Marvel comics for next to nothing from a place we called Hattie's Hock Shop in Redwood Falls, Minnesota. Let's just say Hattie was my dealer.) During his heyday before World War II, Fawcett was

publishing over forty different magazines. A reference is made to *Whiz Bang* in the classic musical *The Music Man*, when Professor Harold Hill is looking for reasons that River City must purchase new band uniforms. He warns parents to look for nicotine stains on their sons' hands, the smell of Sen-Sens on their breath or the sound of jokes from *Captain Billy's Whiz Bang*. Gasp!

Fawcett used his wealth to purchase eight acres on Pelican Lake, opening Breezy Point Lodge in 1921, and paid to have the road from Breezy Point to Pequot Lakes blacktopped for his celebrity guests. Guests included Carole Lombard, Tom Mix, Clark Gable and President Harry Truman. But was there or wasn't there a speakeasy at the award-winning Breezy Point Lodge? To this I would have to say, "Absolutely!"

The Wilford H. Fawcett House is listed on the National Register of Historic Places and is located at Breezy Point Bay on Big Pelican Lake. According to its website (www.breezypointresort.com):

> *For over 80 years additions have been made to complement Captain Billy Fawcett's original dream. Breezy Point Resort now encompasses 3,000 acres with two 18-hole golf courses, a complete boat marina, and approximately 350 lodging units. Though many things have changed over the years, one thing has never changed—our dedication to giving you the finest in personal vacation service possible. Our warmth and hospitality are the ingredients that give our offerings meaning and make the Breezy experience one that our guests return to year after year.*

REVENUERS RAID
NEW ULM, MINNESOTA

The implementation of the Eighteenth Amendment required the United States to form a new department called the Bureau of Prohibition, which employed government agents known as "revenuers" to uphold the new law. The organization was formed in 1920 under the Bureau of Internal Revenue and was made an independent agency within the Treasury Department in 1927. The bureau was later shifted to the Justice Department in 1930 and was eventually overseen by J. Edgar Hoover and the FBI for a brief period of time in 1933. At the repeal of the Eighteenth Amendment, the bureau reverted back to the Treasury Department, where it became the Alcohol Tax Unit of the Bureau of Internal Revenue.

The men who were hired by the Bureau of Prohibition were in charge of collecting taxes on, or halting, the illegal distribution of liquor. They were a reviled group, cruising around in over-sized Packards, armed and dangerous. They were disdained by the public for mistreating or occasionally killing innocent citizens in their zeal to uphold the law. The most famous revenuer was a man named Elliot Ness, who, in 1942, led a group of federal agents known as the "Untouchables" in Chicago, Illinois, in the quest to take down gangster Al Capone.

It seems that, historically, bootleggers were held in higher regard than the agents who stalked them. The following article illustrates the contempt some agents showed toward citizens and business owners.

FEDERAL AGENTS ARREST TWO MEN IN RAIDS HERE

Reinhart and Steinkraus Are Taken To Brown County Jail
DESTROYS REINHART'S SUPPLY OF WINE
Fail to Find Liquor in New Pool Hall Of John Gratz

Four federal agents swept into New Ulm Monday evening, raided two places, confiscated 80 quarts of wine, struck two men, made a couple of arrests and departed into the night for parts unknown.

Agents entered the drink place of Ben Reinhart at 801 North Minnesota Street and went directly to the basement where they destroyed the wine which Mr. Reinhart alleges was his private supply. When they came upstairs, one of their number asked Mr. Reinhart what his name was. When he failed to respond immediately, the agent attempted to slap his face.

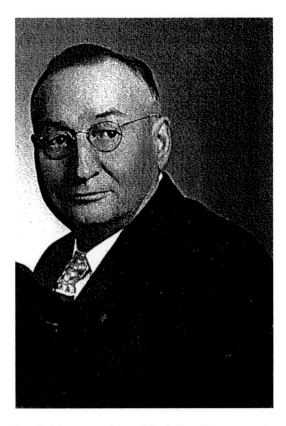

Ben Reinhart, proprietor of Ben's Bar. *Photo courtesy of the Ben Reinhart family.*

STEINKRAUS ARRESTED

At this point in the proceeding, John Steinkraus, who was one of the 25 men in the establishment, stepped forward and declared: "There is not going to be any hitting done here." Mr. Steinkraus attempted to go back of the bar to Mr. Reinhart's assistance when he was stopped by an agent pushing a revolver in his ribs. Mr. Steinkraus was taken into custody for interfering with an officer.

CROWD GATHERS

The raids occurred about 9 p.m. When the agents took Mr. Reinhart and Mr. Steinkraus out on the street preparatory to leading them to the county jail a crowd assembled but there was no disturbance. After they reached the street, Mr. Steinkraus declared that an agent refused to let him put on a pair of gloves which he had in his pocket and struck him over the head.

An attorney was called and he secured consent of the United States Marshal to the release of both men from the county jail before midnight on their own recognizance. The two defendants will go to Mankato on Friday to appear before a United States commissioner.

CONCLUSION

When all is said and done, it behooves us to ask ourselves, "What was the point? Was our country any better off after thirteen years of bullying, deprivation and growing national resentment? Did we learn anything from the years of the Noble Experiment?"

Of course we did. A study of the Prohibition era perfectly illustrates, both socially and economically, the parallels between that peculiar era and the circumstances we face today. It is a flawless formula for demoralizing and bankrupting an entire country. The networks created for contraband liquor back then continue today as routes for illicit tax-free drugs, enriching an underground economy and costing citizens a ridiculous amount of money in the war on drugs. We know the harmful effects of tobacco and alcohol, and we live with those risks. Are drugs so different? Think of the taxes we could collect if drugs were sold in storefronts and not in back alleys. Who profits from a government-imposed black market?

Ruthless corporations continue to bankroll corrupt politicians who don't believe in what they are representing and voting for but will say anything to keep the cash rolling in. An earnest politician working for the people or a reporter reporting the harsh truth is mocked by the media and, in some cases, may be risking his or her life, for the "Masters of the Universe" fear the strength in numbers represented by the beautiful, honest, hardworking people who are the backbone of this country.

The privately held Federal Reserve continues to use open market policies to value our currency on stocks and bonds, charging U.S. citizens interest,

which is paid through our taxes, rather than "we the people" printing our own money with the backing of gold. Extreme political parties are still trying to win elections using Wheeler's "pressure politics" on single-issue campaigns, all the while counting on our failure to see the big picture as we are distracted by their banners and chanting.

We could prove that we learn from our mistakes, but we'd have to be willing to do it. Common sense suggests it is better to be *for* something and have a plan for improvement than to be *against* an issue, which tactic the elite uses to divide and conquer us. We should be working together for the common good. If you don't believe in drinking liquor, taking drugs, having abortions or paying taxes, then be true to yourself and don't do it. Support drug and alcohol rehabilitation, support birth control and sex education or support rewriting the tax code, but don't let unscrupulous power mongers use one emotional issue to take away the power we have together to see that everyone has enough to get by.

Love thy neighbor. Live and let live. R-E-S-P-E-C-T—and all that jazz.

BIBLIOGRAPHY

Aronovici, Carol, and Minnesota Bureau of Women and Children. *Women in Industry in Minnesota in 1918.* Minneapolis, MN: Syndicate Printing Company, 1920.

Billings, J.S. *The Liquor Problem: Summary of Investigations Conducted by the Committee of Fifty, 1893–1903.* Boston: Houghton, Mifflin, 1905.

Boudreaux, D. "Thoughts on Freedom. Alcohol, Prohibition, and the Revenuers." Freeman Online. www.thefreemanonline.org/columns/ thoughts-on-freedom-alcohol-prohibition-and-the-revenuers.

Dwyer, Gerald P., Jr. "Wildcat Banking, Banking Panics, and the Free Banking System in the United States." *Economic Review* (December 1996). Available online at www.frbatlanta.org/filelegacydocs/ACFCE.pdf.

Griffin, G.E. "Federal Reserve: The Enemy of America." American Patriot Friends Network. www.apfn.org.

Gruder, D. "Brief History of United States Banking System." New IQ. www. thenewiq.com/timeline.

"Irving Fisher." Eastern Washington University. http://finance.ewu.edu/ finc335/lectures/Ross%20Westerfield%20Jordan/Fisher.html.

"John Philip Sousa: American Conductor, Composer and Patriot." Sousa and His Band. www.dws.org/sousa/bio.htm.

Lindbergh, Charles A. *United States Senate Hearings on the Federal Reserve Act.* Washington, D.C.: Government Printing Office, 1912.

———. *Why is Your Country at War?* Washington D.C.: National Capital Press, 1917.

Marx, Karl, and Frederick Engels. "Manifesto of the Communist Party." School of Social Sciences, Faculty of Arts at the Australian National University. www.anu.edu.au/polsci/marx/classics/manifesto.html.

Mattix, Rick. "The Lonesome Death of Lloyd Barker: End of the Barker Gang." Good Reads. www.goodreads.com/story/show/7430.The_Lonesome_Death_of_Lloyd_Barker.

McMillin, B. "The Income Tax." *Saturday Evening Post*, May 17, 1913.

Minnesota Historical Society. "Commission of Public Safety." www.mnhs.org/library/tips/history_topics/98safety.html.

———. "Nonpartisan League." www.mnhs.org/library/tips/history_topics/102nonpartisan.html.

Official Website of the Knights of Labor, http://www.knightsoflabor.org.

Okrent, Daniel. "Wayne B. Wheeler the Man Who Turned Off the Taps." Smothsonian.com: www.smithsonianmag.com/history-archaeology/Wayne-B-Wheeler-The-Man-Who-Turned-Off-the-Taps.html?c=y&page=1.

"Public Enemies vs. J. Edgar Hoover." History Search Writer. www.historyresearchwriter.com/publicenemies.htm.

"Shootout With the 'Ma' Barker Gang." Watersheds.org. www.watersheds.org/education/richards/shootout.htm.

Time. Milestone section. May 8, 1933.

"Walter W. Liggett." Freedom Forum Journalists Memorial. www.newseum.org/scripts/Journalist/Detail.asp?PhotoID=691.

Wikipedia. "Minnesota Nice." http://en.wikipedia.org/wiki/Minnesota_nice.

———. "Pressure Politics." http://en.wikipedia.org/wiki/Pressure_politics.

———. "Warren G. Harding." http://en.wikipedia.org/wiki/Warren_G._Harding.

Woodbury, M. L. *Stopping the Presses: The Murder of Walter Liggett.* Minneapolis: University of Minnesota Press, 1995.

Writer, S. "Farm Price Fixing Vital Says Olson." *New York Times*, 1931.

INDEX

ABOUT THE AUTHOR

Author of *Hidden History of the Minnesota River Valley*, Beth Johanneck was born a Minnesota farmer's daughter, with seven brothers and a fabulous sister, and raised on a farm near the tiny community of Wabasso. During her childhood, she was inspired by her mother's creativity and her father's gift for storytelling. She received a bachelor's degree in business from Southwest State University in Marshall, Minnesota, and grabbed an opportunity to work for a tourism office within the central part of the Minnesota River Valley. She currently resides in the Twin Cities but hasn't forgotten her rural roots, publishing the "Minnesota Country Mouse Folk Blog."

Visit us at
www.historypress.net